Writers

 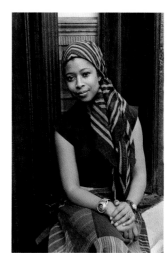 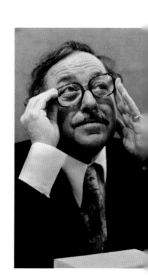

The Quantuck Lane Press *New York*

Writers

Photographs by Nancy Crampton

Foreword by Mark Strand

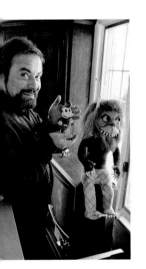 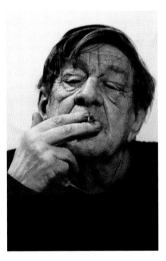 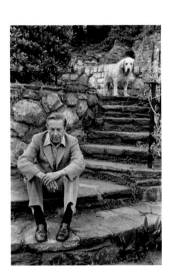 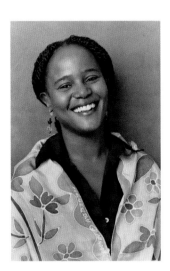 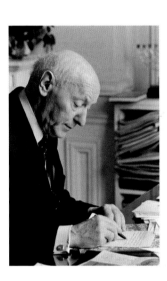

Writers
Nancy Crampton

The text of this book is composed in Claridge
with the display in Clarendon.
Book design and composition by Laura Lindgren.
Manufacturing by Mondadori Printing, Verona.

Library of Congress Cataloging-in-Publication Data
Crampton, Nancy.
 Writers / photographs by Nancy Crampton ; foreword by Mark Strand.— 1st ed.
 p. cm.
 Includes bibliographical references and index.
 ISBN 1-59372-019-X (alk. paper)
 1. Authors, American—Portraits. 2. Portrait photography—United States.
3. Crampton, Nancy. 4. Authors, American—Biography—Anecdotes. I. Title.
 TR681.A85C68 2005
 810.9'0054—dc22 2005003448

The Quantuck Lane Press
www.quantucklanepress.com
Distributed by W. W. Norton & Company, Inc.
500 Fifth Avenue
New York, N.Y. 10110
www.norton.com

W. W. Norton & Company Ltd.
Castle House
75/76 Wells Street
London WIT 3QT

 2 3 4 5 6 7 8 9 0

To Seymour Britchky,
who helped me with this book in every way

Contents

Foreword

Many of us while reading a book will check the author photograph several times in hopes of discovering some connection between what we see there and what we are experiencing as readers. It is as if the face were the door to the dark room of the imagination, which may be why we find photographs of writers and artists more intriguing than photographs of other people. And yet we never find what we are looking for, nor do we know if what we are looking for really exists or if we could recognize it if it did. Wild hair, taut lips, sunken cheeks, a penetrating gaze could belong to anyone. Still, we continue to search. But so far, no face has ever illuminated a text, nor has a text ever told us that it came into existence because of a face.

Nancy Crampton's photographs of writers are more varied than the typical head shot one sees on book jackets. There is a certain guilelessness about them, an open, responsive interest in the subject whether it is a face at its most opaque and masklike or one at its most vulnerable and inviting. We may be looking at the photo of a face, but what we feel is the presence of Crampton's attention. The issue of discovering a connection between the photographs of authors and what we have experienced in one or many of their books is put aside. Certainly, Crampton is not burdened with connecting the two. There is more to her photographs than just the face of an author. The positioning of the body, the angle of the head, the sudden or gradual fall of light—all play a part in creating pictures that magically combine the immediacy of a snapshot and the premeditated calm of a formal portrait. None of this would be possible without the willing participation of the subjects themselves, but it is Nancy Crampton's directness—her naturalness and lack of theatricality—that is the foundation of their willingness.

On the pages that face the photographs are short statements by the writers, having to do with what they hope their writing will accomplish, or how they go about it, or what it is about. The statements have been gathered from interviews, lectures, and essays, and they vary widely. The visual and the verbal side by side do not shed light on each other so much as form a conjoining of presences, one drawn from within, the other from without. What the camera could not do, the author has done, and what the author could not do Nancy Crampton has done. The result is an incomparably interesting collection of visions and insights.

Mark Strand

Writers

Isaac Bashevis Singer

I don't know if I should call myself a mystic, but I feel always that we are surrounded by powers, by mysterious powers, which play a great part in everything we are doing. I would say that telepathy and clairvoyance play a part in every love story. Even in business. In everything human beings are doing. For thousands of years people used to wear woolen clothes and when they took them off at night they saw sparks. I wonder what these people thought thousands of years ago of these sparks they saw when they took off their woolen clothes? I am sure that they ignored them and the children asked them, "Mother what are these sparks?" And I am sure the mother said, "You imagine them!" People must have been afraid to talk about the sparks so they would not be suspected of being sorcerers and witches. I say that we too in each generation see such sparks which we ignore just because they don't fit into our picture of science or knowledge. And I think that it is the writer's duty, and also pleasure and function, to bring out these sparks.

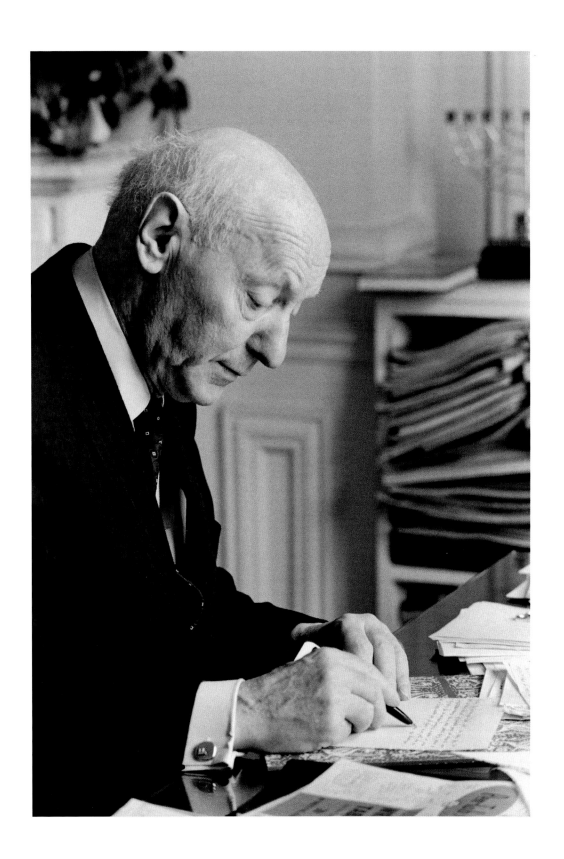

Nelson Algren

I think just wanting to write doesn't necessarily mean that you really want to write. When I run into many people, as I have for a long time, who say, when they introduce themselves, "I want to write," this doesn't mean they really want to write. Very few people really want to write. What they want is what I wanted in high school: I wanted somebody or some means to distinguish me from everybody else. Why I would pick on writing was just a mechanical facility.... It was just the easiest way of finding out, to borrow James Baldwin's recent phrase, what my name is, who am I? If I had been a hundred ninety-six pounds and six-four, I would have found my name by becoming an all-state football player or something. I mean you write or you play football or you paint, or you become a pimp, or you steal, or you become a politician, in an accidental way.... This is just the same reason that a girl always wants to be the prettiest one in the class. She wants to be somebody. But this doesn't mean you really want to write.

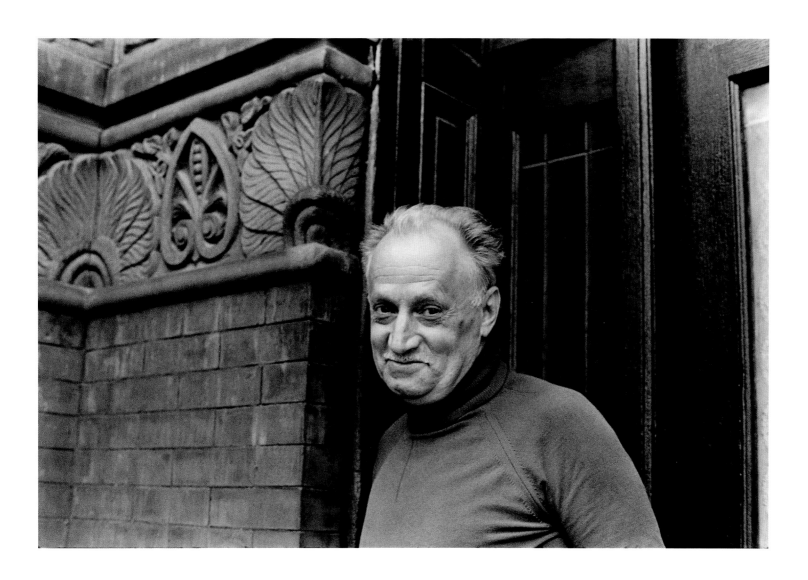

Alice Walker

Near the end of writing *The Temple of My Familiar,* I felt as if I were walking in a circle of magic, and this made me indescribably happy. But nothing could have prepared me for the "magic" that occurred on the very last day of writing. I had just completed the paragraph in which Suwelo contemplates the painting of Lissie as Lion, and was hurrying up the hill to my studio to type it on my Mac Plus, when I noticed what appeared to be a tan plastic dry-cleaner's bag—without my glasses this was a blur—lying some distance out in the field. A neatnik to my soul—I will pick up trash anywhere—I moved quickly to remove this unsightly object, wondering all the while how it came to be there. But then, when I was a few steps away, I saw that it wasn't a discarded dry-cleaner's bag but a large, tawny cat, a miniature "lion," lying at ease, calmly looking at me. I'd never seen it before; I haven't seen it since. I began to smile and fairly skipped along to my studio.

I felt that this "omen" was Lissie's sign of approval for the ending I had just written, and also a sign from the animals that in *The Temple of My Familiar* I had kept to our collective vision of reality. And that we were united in our sense of peace at the outcome.

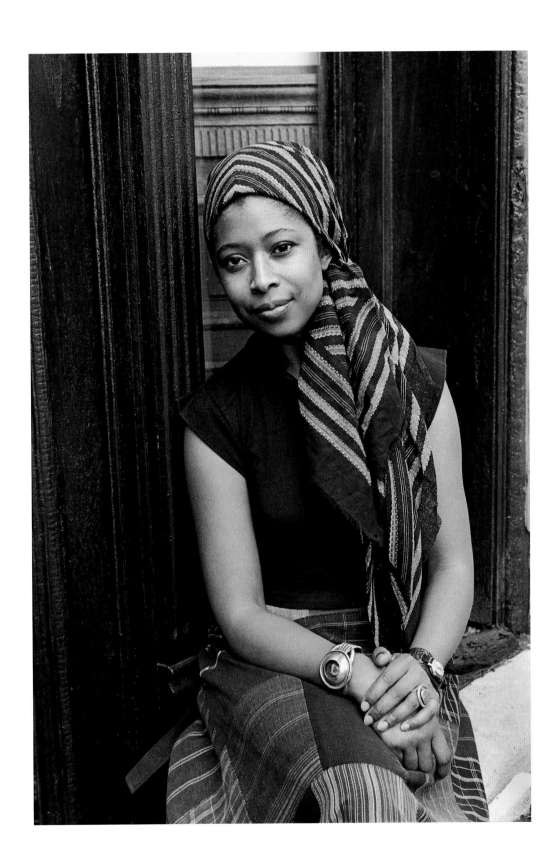

James Dickey

On the inspiration toward Deliverance:

After one of those big Italian meals, I was lying in bed in the full southern Italian sunlight, which is really tremendously pleasant, and it occurred to me that some events that I had undergone, or lived through, I guess you could say, plus some things that I had heard about and some things that I could invent, would go together into a kind of unified or coherent story. I had never written any stories or novels or anything like that before, but it occurred to me that it might just work out fine. So I got up from bed, reluctantly, because I was so sleepy, and I made a few notes—I'd say half a page in longhand—and went back to sleep contented. And that was the beginning. I mean I knew the whole story in five minutes or less, or maybe even one minute.

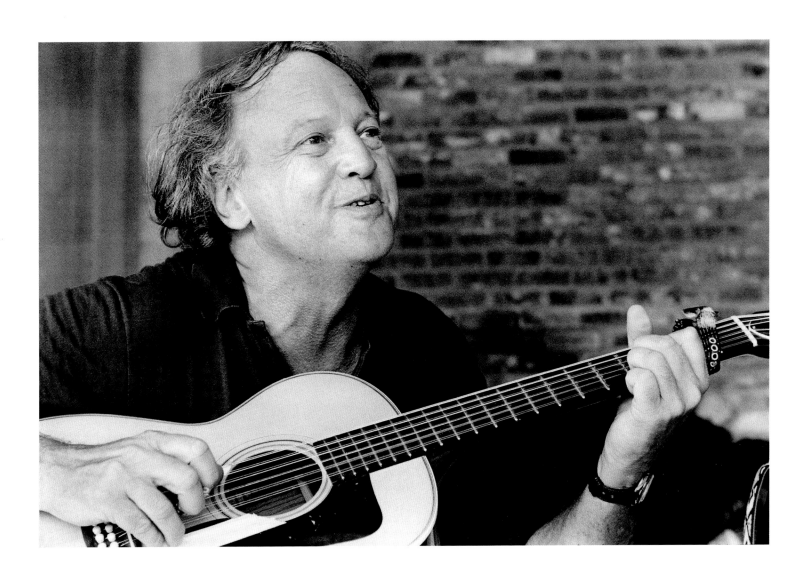

John Cheever

Any precise documentation of one's immaturity is embarrassing, and this I find from time to time in my stories, but this embarrassment is redeemed for me by the memories the stories hold for me of the women and men I have loved and the rooms and corridors and beaches where the stories were written. My favorite stories are those that were written in less than a week and that were often composed aloud. I remember exclaiming: "My name is Johnny Hake!" This was in the hallway of a house in Nantucket that we had been able to rent cheaply because of the delayed probating of a will. Coming out of the maid's room in another rented house I shouted to my wife: "This is a night when kings in golden mail ride their elephants over the mountains!" The forbearance of my family has been inestimable. It was under the canopy of a Fifty-ninth Street apartment house that I wrote, aloud, the closing of "Goodbye, My Brother." "Oh, what can you do with a man like that?" I asked, and closed by saying, "I watched the naked women walk out of the sea!" "You're talking to yourself, Mr. Cheever," the doorman said politely, and he too—correct, friendly, and content with his ten-dollar tip at Christmas—seems a figure from the enduring past.

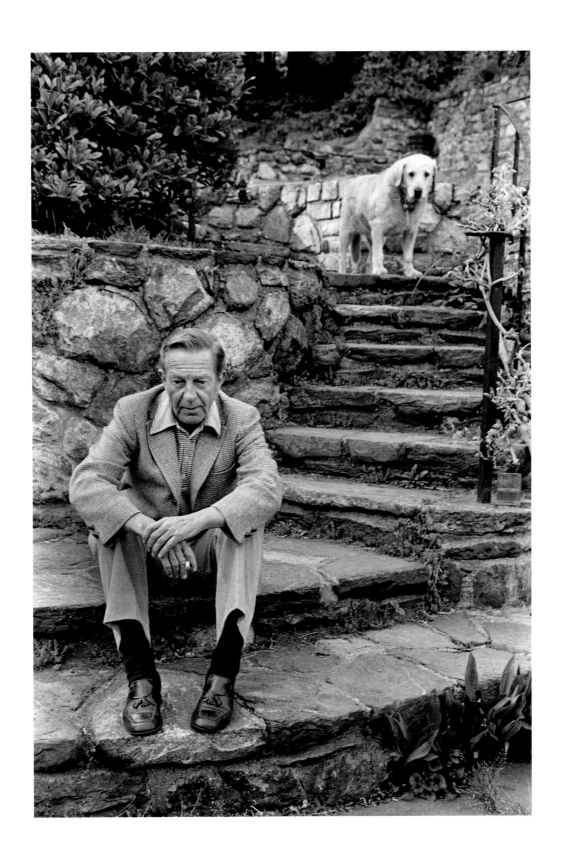

Saul Bellow

It is the deep conviction of vast numbers of individuals that they have no proper story. Their personal experience of storylessness, and hence of valuelessness, is very great. Dramatic resolutions are lacking—loves, no one believes in; flights, captivities, wilderness campaigns, the founding of colonies, explorations, the adventures which for centuries were made possible by an expanding world, all these are absent. Nevertheless people still conceive of themselves as *actors* and *characters*. They are prepared but they are not called into action. They feel like unemployed extras; they stand ready and have nothing to do but bear passive, humiliating witness to the greater significance of the new man-made world. Joyce meant to say, I think, that there is remaining significance in myth which sustains the individual. The collective life of mankind he does not admire. History, he agrees with Marx, is a nightmare from which we struggle to awaken. But myth, an extract from the experience of the race, can, he feels, give meaning to the life of the individual and sustain him invisibly. Art— the fresh feeling, new harmony, the transforming magic which by means of myth brings back the scattered distracted soul from its modern chaos—art, not politics, is the remedy.

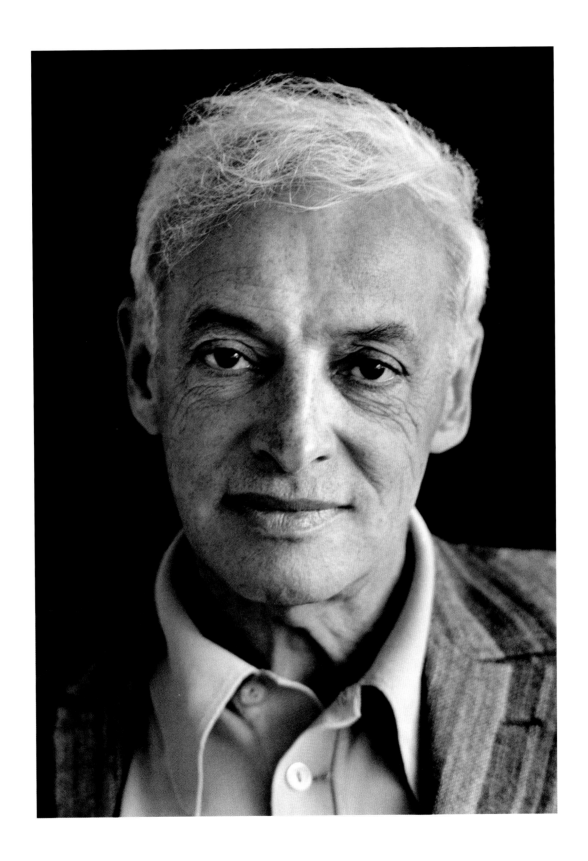

Irwin Shaw

Why does a man spend fifty years of his life in an occupation that is often painful? I once told a class I was teaching that writing is an intellectual contact sport, similar in some respects to football. The effort required can be exhausting, the goal unreached, and you are hurt on almost every play; but that doesn't deprive a man or a boy from getting peculiar pleasures from the game.

Among the pleasures of writing is the reward of the storyteller, sitting cross-legged in the bazaar, filling the need of humanity in the humdrum course of the ordinary day for magic and distant wonders, for disguised moralizing that will set everyday transactions into larger perspectives, for the compression of great matters into digestible portions, for the shaping of mysteries into sharply edged and comprehensible symbols.

Then there is the private and exquisite reward of escaping from the laws of consistency. Today you are sad and you tell a sad story. Tomorrow you are happy and your tale is a joyful one. You remember a woman whom you loved wholeheartedly and you celebrate her memory. You suffer from the wound of a woman who treated you badly and you denigrate womanhood. A saint has touched you and you are a priest. God has neglected you and you preach atheism.

In a novel or a play you must be a whole man. In a collection of stories you can be all the men or fragments of men, worthy and unworthy, who in different seasons abound in you. It is a luxury not to be scorned.

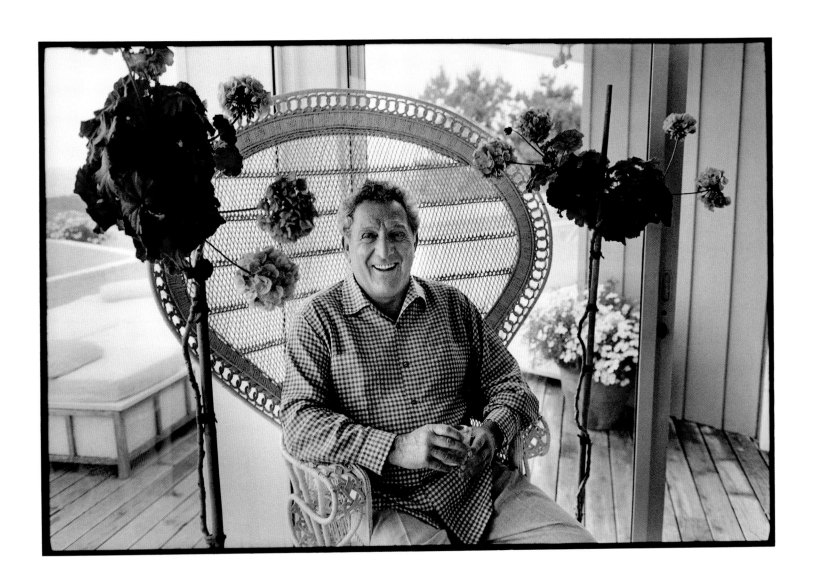

Albert Murray

I'm an American, that's all. I was already an American before I was ever conscious that I was black. I was already breathing, I was already hearing railroad trains, I was already hearing sawmill whistles, I was already hearing automobiles, I was hearing the English language. I looked around and saw all these different people, and they looked like people that belonged around me. Some of them were white, some of them were Indian, some of them were Creole, and so on. That some talked one way and some another seemed natural. That there were conflicts seemed natural. Conflicts exist just about everywhere.

When I hear the term *black writer*, certain alarms go off. Remember, the last thing I want to be mistaken for is a spokesman. If I'm not one of the best living American writers, no thanks for being one of the best living black writers. I'm trying to make sense of all American culture, using the Hemingway principle of writing about what you know. You achieve universality through particulars, so if a critic says, "Murray has mastered the black idiom," I'm proud of that. I would also be proud if somebody said I'd mastered French, Italian, Latin, or the stream-of-consciousness technique. I'm striving to be a representative twentieth-century American writer.

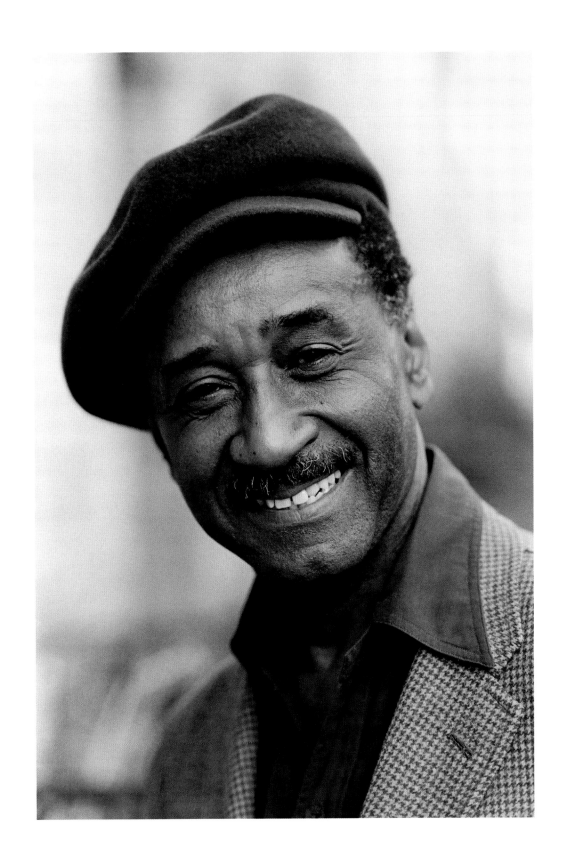

W. H. Auden

The social and political history of Europe would be what it has been if Dante, Shakespeare, Michelangelo, Mozart et al. had never lived. A poet, *qua* poet, has only one political duty, namely, in his own writing to set an example of the correct use of his mother tongue which is always being corrupted. When words lose their meaning, physical force takes over. By all means, let a poet, if he wants to, write what is now called an "engagé" poem, so long as he realizes that it is mainly himself who will benefit from it. It will enhance his literary reputation among those who feel the same as he does.

I can't understand—strictly from a hedonistic point of view—how one can enjoy writing with no form at all. If one plays a game, one needs rules, otherwise there is no fun. The wildest poem has to have a firm basis in common sense, and this, I think, is the advantage of formal verse. Aside from the obvious corrective advantages, formal verse frees one from the fetters of one's ego.

A friend of mine, Dorothy Day, had been put in the women's prison at Sixth Avenue and Eighth Street for her part in a protest. Well, once a week at this place, on Saturday, the girls were marched down for a shower. A group were being ushered in when one, a whore, loudly proclaimed:

> *Hundreds have lived without love,*
> *But none without water…*

a line from a poem of mine which had just appeared in *The New Yorker*. When I heard this, I knew I hadn't written in vain!

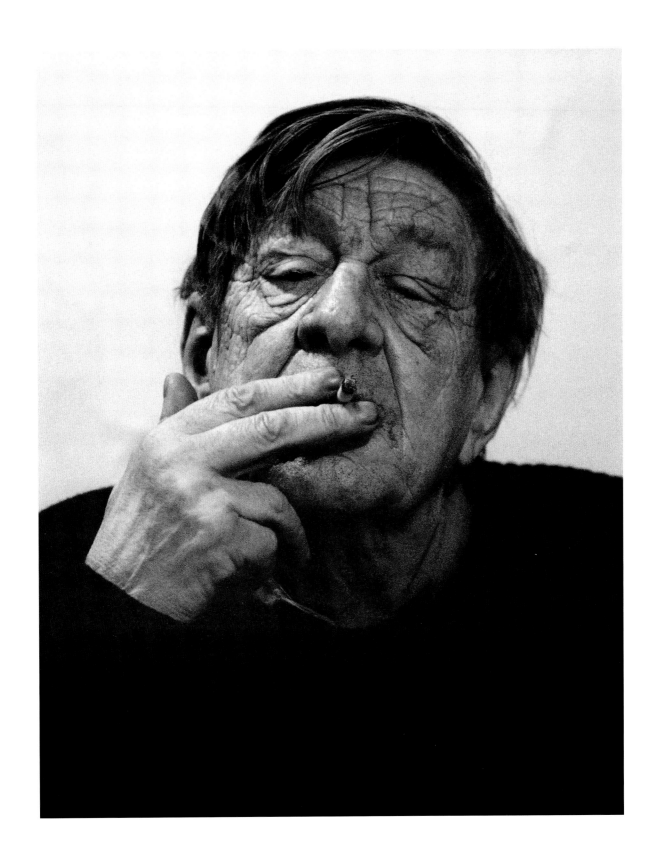

John Updike

From earliest childhood I was charmed by the materials of my craft, by pencils and paper and, later, by the typewriter and the entire apparatus of printing. To condense from one's memories and fantasies and small discoveries dark marks on paper which become handsomely reproducible many times over still seems to me, after nearly thirty years concerned with the making of books, a magical act, and a delightful technical process. To distribute oneself thus, as a kind of confetti shower falling upon the heads and shoulders of mankind out of bookstores and the pages of magazines, is surely a great privilege and a defiance of the usual earthbound laws whereby human beings make themselves known to one another. This blithe extension of the usual limitations of space is compounded by a possible defiance of the limitations of time as well—a hope of being read, of being heard and enjoyed, after death. Writing is surely a delicious craft, and the writer is correctly envied by others, who must slave longer hours and see their labor vanish as they work, in the churning of human needs.

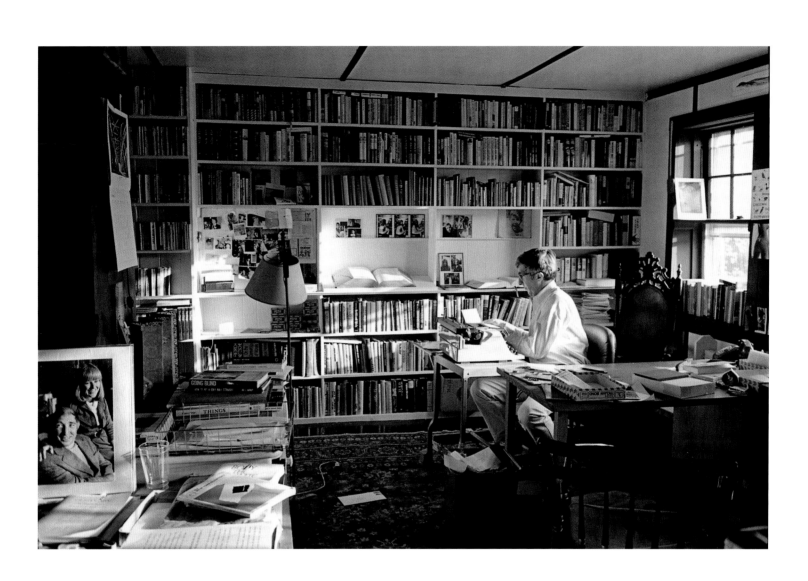

Alfred Kazin

My pivotal experience of the raw hurting power that a book could have over me came when I first read *Oliver Twist*. I was twelve years old, sick with a fever in my narrow little bedroom, and frightened of the book as soon as Oliver fell into the hands of Fagin and his gang. But as I read on, I realized that in Dickens there are happy chapters in the country, among the rich, for all the cruel, scary chapters in London's dark underworld: city and country, dark and light, hell and heaven, cruelty and benevolence, destitution followed by lots of sunshiny moneyed comfort, a happy escape followed by recapture. Then Fagin, whom Dickens was always calling "the Jew," with his lisp and evil grin, would address the helpless Oliver with sinister sweetness as "My dear!" and once again frighten me as he frightened Oliver.

I didn't know Jews like Fagin. I didn't expect that anyone could think of a Jew as a master criminal instructing the young in crime. But what got to me most was Dickens's relentlessness in telling his story. He had put me in his power for life.

There was nothing to look at from my bed but a thin strip of wall next to the window, which opened on a fire escape. I was so shaken and seized by *Oliver Twist* that even when I put the book down I could see it going on, figure by figure, line by line, on the wall itself. Confined as I felt by my narrow room, by my bed, by fever, I felt a strange if awful happiness. *Oliver Twist* was all around me and in me. I wanted never to get away from its effect. There was something in this I had to track down: why was Dickens compelled to write like that, and why did it work on me like a drug? Since that was the literary problem I represented to myself, I had to figure it out for myself. That was how I started as a critic.

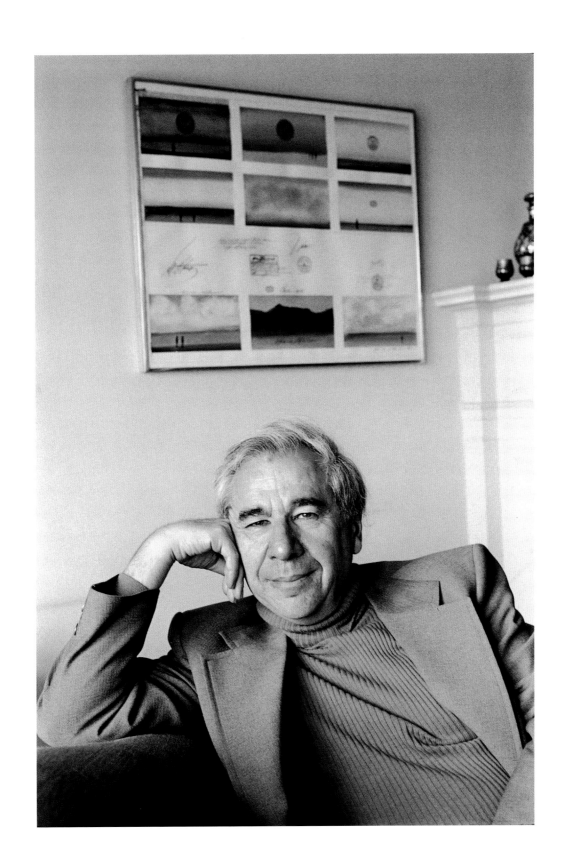

Anne Sexton

When I am writing a poem, I feel I am the person who should have written it. Many times I assume these guises; I attack it the way a novelist might. Sometimes I become someone else, and when I do, I believe, even in moments when I'm not writing the poem, that I am that person. When I wrote about the farmer's wife, I lived in my mind in Illinois; when I had the illegitimate child, I nursed it—in my mind—and gave it back and traded life. When I gave my lover back to his wife, in my mind, I grieved and saw how ethereal and unnecessary I had been. When I was Christ, I felt like Christ. My arms hurt; I desperately wanted to pull them in off the Cross. When I was taken down off the Cross and buried alive, I sought solutions; I hoped they were Christian solutions.

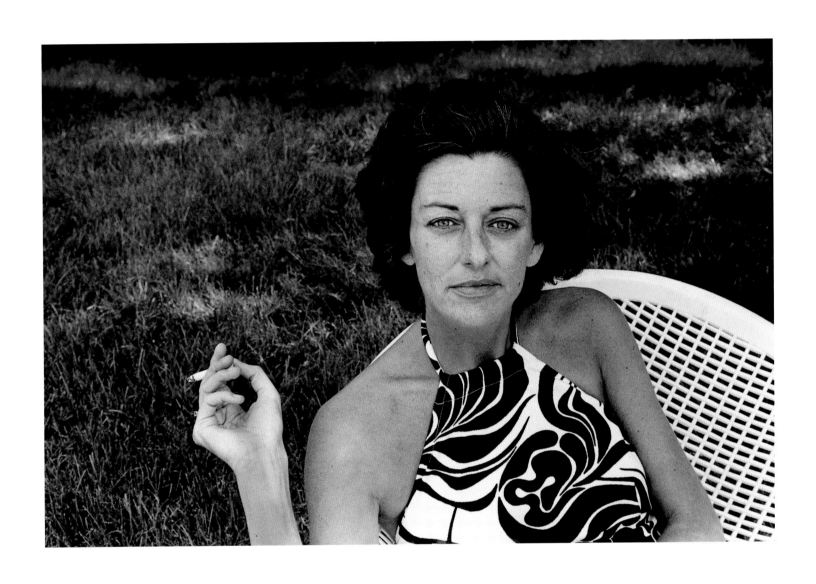

Robert Lowell

Almost the whole problem of writing poetry is to bring it back to what you really feel, and that takes an awful lot of maneuvering. You may feel the doorknob more strongly than some big personal event, and the doorknob will open into something that you can use as your own. A lot of poetry seems to me very good in the tradition but just doesn't move me very much because it doesn't have personal vibrance to it. I probably exaggerate the value of it, but it's precious to me. Some little image, some detail you've noticed—you're writing about a little country shop, just describing it, and your poem ends up with an existentialist account of your experience. But it's the shop that started you off. You didn't know why it meant a lot to you. Often images and often the sense of the beginning and end of a poem are all you have—some journey to be gone through between those things; you know that, but you don't know the details. And that's marvelous; then you feel the poem will come out. It's a terrible struggle, because what you really feel hasn't got the form, it's not what you can put down in a poem. And the poem you're equipped to write concerns nothing that you care very much about or have much to say on. Then the great moment comes when there's enough resolution of your technical equipment, your way of constructing things, and what you can make a poem of, to hit something you really want to say. You may not know you have it to say.

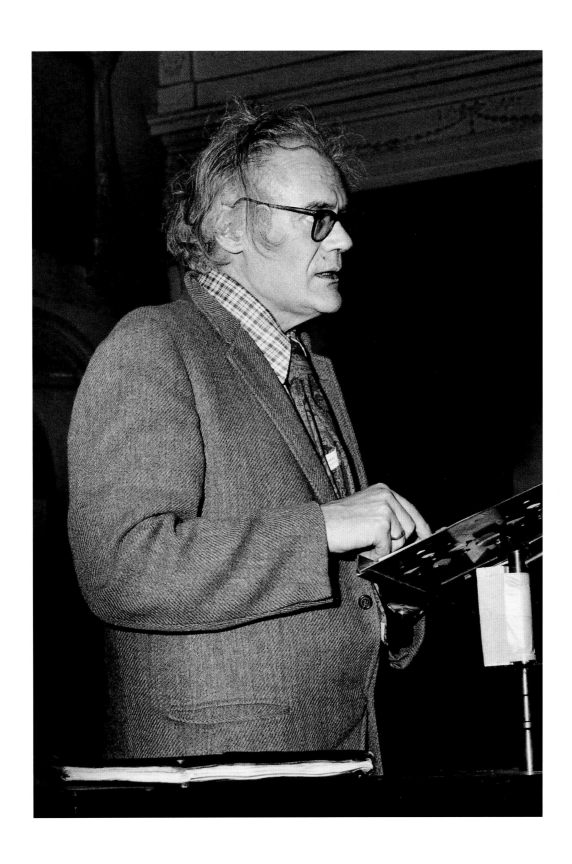

Alix Kates Shulman

To me writing always involves reassessing one's life and coming to some larger understanding. Usually the subjects and themes that attract me are those that have been sources of personal conflict or confusion. Motherhood is such a theme. Though personal transformation is never my purpose in writing, it usually happens that when I have finished a book I find my demons laid to rest. I believe that if the writer is diligent and lucky, she gains clarity about life in the course of writing a book.

It's always difficult to write honestly of one's deepest feelings, particularly without the protective veil of fiction. But the more difficult, the more rewarding if one succeeds. Rewarding not only to the work but to one's peace of mind. Once I get past the initial inhibitions that say, *No you must not write about this!* then honesty is both exhilarating and soothing.

The current emphasis on pain and betrayal in memoirs may be largely a matter of fashion. Memory does tend to preserve extreme emotions, sometimes joyous, often painful, and moments of crisis or danger. Perhaps this is an evolutionary adaptation for survival—so you'll remember the dangers and watch out. But remembering the shape of an entire life is another matter. That involves imagination as much as memory, regardless of the nature of the memories recorded.

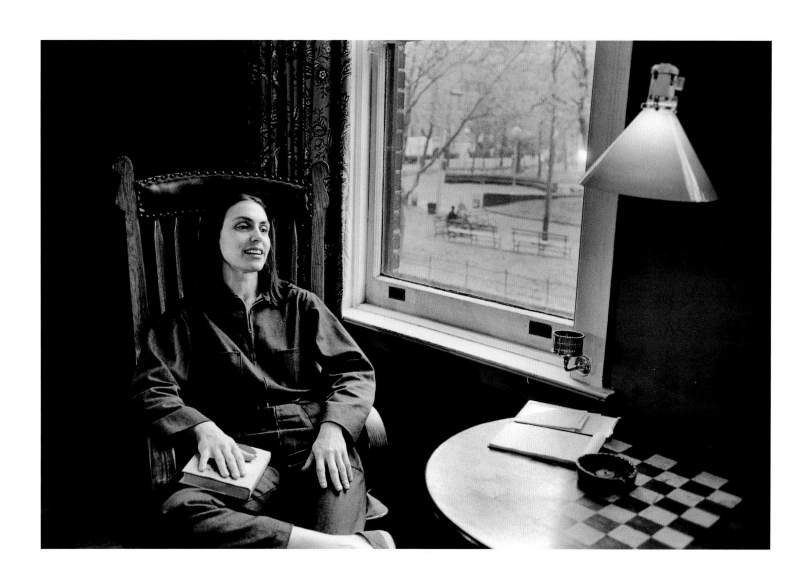

Maurice Sendak

It is a Sunday in the late 1930s—the relatives have come to our house, as usual, to eat everything they can sink their teeth into. And that, in my feverish child's imagination, meant me too possibly! It seems, in retrospect, they even left with the furniture. They were a huge bunch who would roughly snatch you up at any moment. They'd jabber loudly in a foreign tongue—kiss, pinch, maul, and hug you breathless, all in the name of love. Their dread faces loomed—flushed, jagged teeth flaring, eyes inflamed, and great nose hairs cascading, all oddly smelly and breathy, all dangerous, all growling, all relatives. We obeyed. We respected them. It would take a long time to learn to love them. I would, at a later date, take my revenge and turn them into the Wild Things.

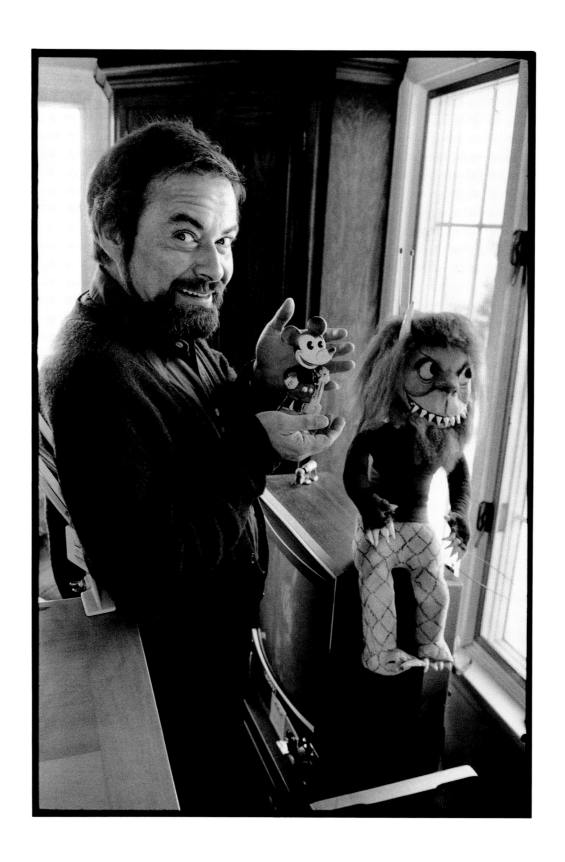

William Steig

Among the things that affected me most profoundly as a child—and consequently as an adult—were certain works of art: Grimms' fairy tales, Charlie Chaplin movies, Humperdinck's opera *Hansel and Gretel,* the Katzenjammer Kids, *Pinocchio. Pinocchio* especially. I can still remember the turmoil of emotions, the excitement, the fears, the delights, and the wonder with which I followed Pinocchio's adventures.

I am well aware not only of the importance of children—whom we naturally cherish and who also embody our hopes for the future—but also of the importance of what we provide for them in the way of art; and I realize that we are competing with a lot of other cultural influences, some of which beguile them in false directions.

Art, including juvenile literature, has the power to make any spot on earth the living center of the universe; and unlike science, which often gives us the illusion of understanding things we really do not understand, it helps us to know life in a way that still keeps before us the mystery of things. It enhances the sense of wonder. And wonder is respect for life. Art also stimulates the adventurousness and the playfulness that keep us moving in a lively way and that lead to useful discovery.

Books for children are something I take very seriously. I am hopeful that more and more the work I do for children, as well as the work I do for adults, will approach the condition of art.

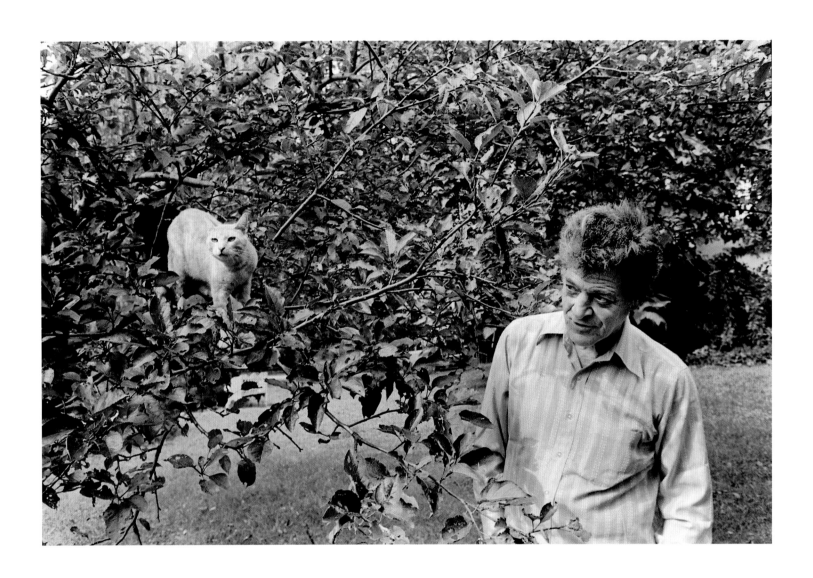

James Jones

I have found a title for this book. *From Here to Eternity.* Taken from the "Whiffenpoof" song, of Yale drinking fame. It goes: "We are little black sheep who have gone astray, baa...baa...baa. Gentlemen songsters out on a spree, doomed from here to eternity. God have mercy on such as we. Baa, etc." Maybe it's maudlin, but so am I. I get chills every time I sing it, even when sober.

Writing is my life; if I couldn't write I don't know where the hell I'd be. But writing without publishing is like eating without swallowing.

One thing I do know: I can write, with true emotion and perception and the right values of things I've seen. In fact, I can write so damned well that that is my main trouble. I can write anything, I can write everything, but I haven't yet learned how to make it properly selective. Any time a scene hits me emotionally I can sit down and write it, with the true emotion. But too many scenes lead off into tangents and blind alleys from which I can't extricate myself.

The trick is to release the trigger of your conscious mind, it seems to me, and then things write themselves that you have forgotten you even knew. If you could only just reach that state and maintain it, it would be wonderful. Only I can't, and none of the yoga paths seem to help me any because I'm not interested in spiritual attainment but only writing and in putting down the truth of life.

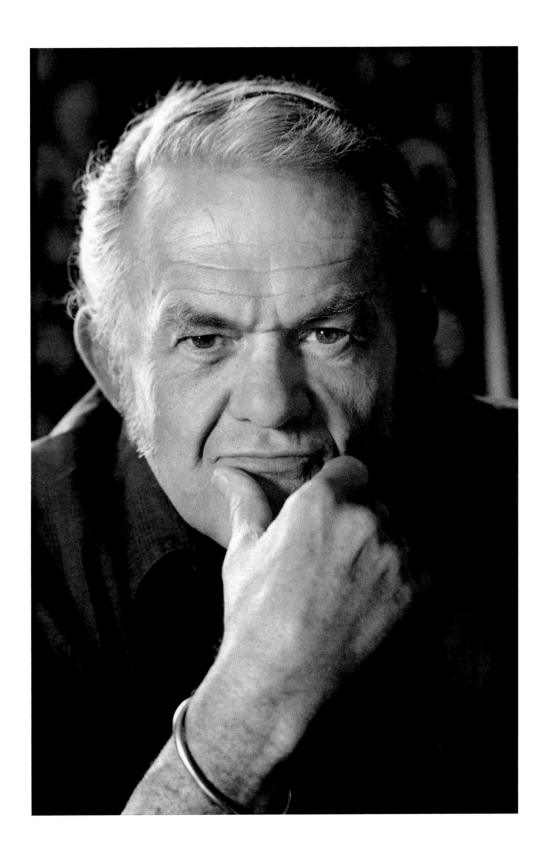

Ralph Ellison

Perhaps the discomfort about protest in books by Negro authors comes because since the nineteenth century American literature has avoided profound moral searching. It was too painful and besides there were specific problems of language and form to which the writers could address themselves. They did wonderful things, but perhaps they left the real problems untouched. There are exceptions, of course, like Faulkner, who has been working the great moral theme all along, taking it up where Mark Twain put it down.

I feel that with my decision to devote myself to the novel I took on one of the responsibilities inherited by those who practice the craft in the United States: that of describing for all that fragment of the huge diverse American experience which I know best, and which offers to me the possibility of contributing not only to the growth of the literature but to the shaping of the culture as I should like it to be. The American novel is in this sense a conquest of the frontier; as it describes our experience, it creates it.

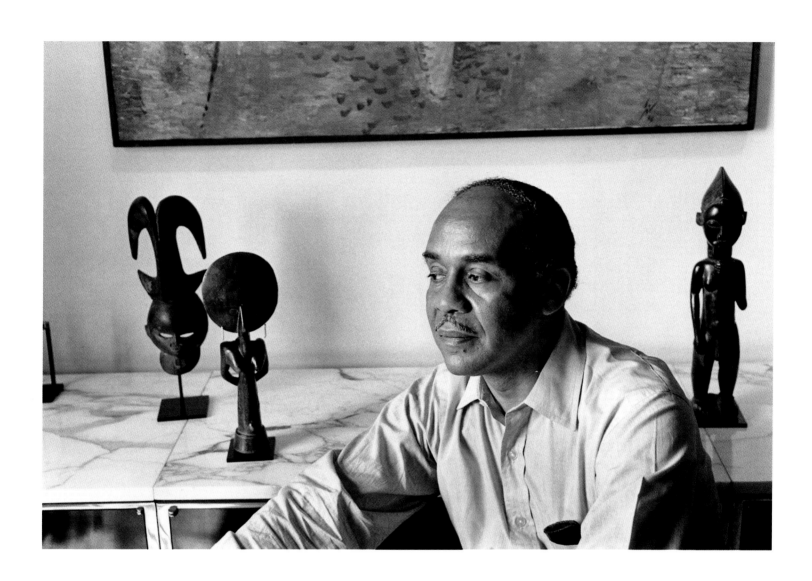

Joseph Heller

Writing fiction, and probably nonfiction, is basically a manipulative experience that is rather cold and detached. Manipulative in the sense that one is aware of a "wish" and an obligation—if that wish is to be fulfilled—of being intriguing. Of being appealing and of manipulating the responses of the reader. Or at least gaining his attention, engineering a response, creating enough interest. The "detached" part comes in when I am writing about an experience that tended in actuality to be pathetic. In writing it I am not experiencing pathos. I may have experienced it before, and I will recognize the intrinsic possibilities of that scene. The death of Snowden in *Catch-22* as I described it is still vivid in my mind. I knew what impact I wanted that to have. And each time I've read from that, no matter how many people are in the auditorium, there will be total silence until I'm finished.

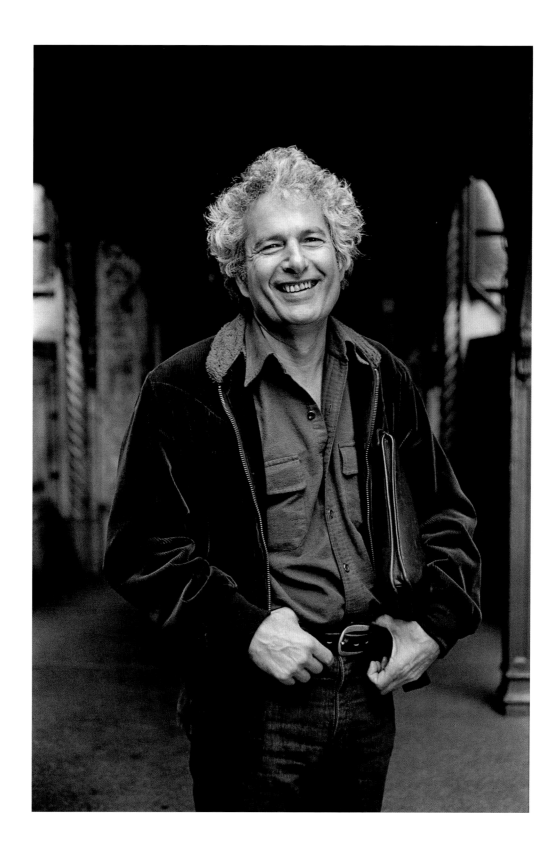

Dwight Macdonald

I've sold but not, with one large exception, out. That is, I've had to make my living by my typewriter but I've written as well as I could and on subjects of my own choice. The large exception was 1929–1936 when I was a staff writer on *Fortune,* a hack in Luce's stables; the subjects were assigned and the style was a "house" style, not my own. Excuses swarm: I was young; the articles weren't signed; hard times, and I needed the dough to support my aging mother, and myself. Also I learned the tricks of the trade—professional education: how to research the facts and how to present them (everything on the same topic should go into the same place, an editor once explained, worth the whole six years). By 1936, I'd learned all I could from Luce journalism and had become profoundly bored with its dynamic simplifications. I was tempted, morally, to keep selling out—I was by then getting $10,000 a year, an interesting salary in those primitive days—but it had become neurologically impossible: I kept falling asleep in the very act of prostitution.

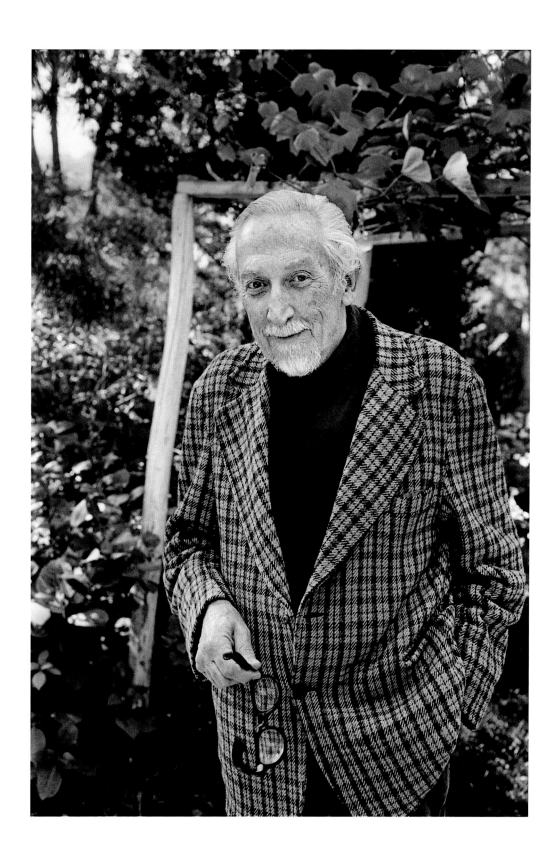

Richard Wilbur

I take no pleasure in mere form, and I've never said to myself, "I think I'll write a sonnet." I've never written a sonnet or even a rondeau except by sort of blundering into it—finding that some material that was washing around in my head wanted to take that form.... Mostly I don't use so-called traditional forms. I just start writing and let the lines break off where they want to break off and, if they seek to rhyme, it's they that are doing the rhyming, not I. I have the feeling that the material chooses the form. I have no quarrel at all with Emerson. He said, "Not meter, but meter-making argument makes poetry," and I think that's true. I simply write a kind of free verse that ends by rhyming much of the time.... Non-rhyming poets don't know it, and so I like to say it. If you take any two words that rhyme, there operates, as Victor Hugo said, between them a kind of obligation to produce metaphor. If I say *hook-book* to you, it's not the same as if I said *brush-stadium.* There's some kind of implicit, magical demand made on you by the fact that *hook* and *book* sound a bit alike, and your mind starts trying to pull them together in some way or other.... The mind is actually set loose by this search for a rhyme that will make some kind of sense.... Rhyme can be a great liberator of the unconscious.

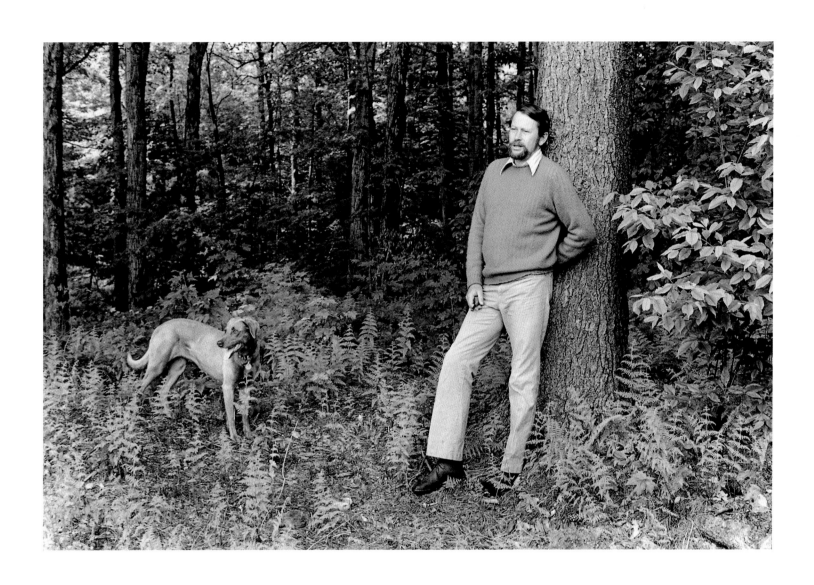

Derek Walcott

I come from a place that likes grandeur; it likes large gestures; it is not inhibited by flourish; it is a rhetorical society; it is a society of physical performance; it is a society of style. The highest achievement of style is rhetoric, as it is in speech and performance. It isn't a modest society. A performer in the Caribbean has to perform with the right flourish. A calypsonian performer is equivalent to a bullfighter in the ring. He has to come over. He can write the wittiest calypso, but if he's going to deliver it, he has to deliver it well, and he has to hit the audience with whatever technique he has. Modesty is not possible in performance in the Caribbean, and that's wonderful. It's better to be large and to make huge gestures than to be modest and do tiptoeing types of presentations of oneself. Even if it is a private platform, it is a platform. The voice does go up in a poem. It is an address, even if it is to oneself. And the greatest address is in the rhetoric. I grew up in a place in which if you learned poetry, you shouted it out. Boys would scream it out and perform it and do it and flourish it. If you wanted to approximate that thunder or that power of speech, it couldn't be done by a modest voice in which you muttered something to someone else. I came out of that society of the huge gesture.

Grace Paley

How interesting it is to be brought up with a couple of languages around you. There is something about getting these two tunes, three tunes, in your ear. And English is very receptive to this. I mean English really warmly receives all these other languages. At least it does in the United States at the present time. So I feel that my language was shaped by the fact that in my house normally Russian was spoken. English was spoken. You never knew when people were going into one language or another. And Yiddish less so because only my grandmother spoke that. So these languages kind of speak to one another.

George Plimpton

When I was a youngster I was convinced that the highest achievement one could hope for in life was to play baseball in the major leagues. My idea of the perfect death was to be beaned by a heavily bearded pitcher late in my career. In my particular case I wanted to pitch. My hero was the New York Giants' ace pitcher of the time, Carl Hubbell, tall, gawky, and master of the screwball. He had thrown so many of them—a kind of reverse curve—that his arm was literally deformed. You could see it when he walked out to the mound, the palm turned slightly outward. When I was eleven I walked around with my arm turned out in the hope I'd be mistaken for a screwball pitcher. My father made me stop it. He said it looked as if I had tumbled out a window and my parents didn't have enough money to have the broken arm set properly.

The real game I played in was a postseason affair in Yankee Stadium between teams from the National and American leagues headed respectively by Willie Mays and Mickey Mantle. Mays had left New York with the Giants the season before. His wondrous play had been sorely missed in New York and about twenty thousand turned out to see the game. My involvement occurred in a pregame affair—the idea being that I was to pitch to both lineups, the team that scored the most runs dividing a thousand-dollar prize put up by *Sports Illustrated.*

One of the recurring truths about my type of participatory journalism is that the results have very little to do with what happens in daydreams. I had an awful time in Yankee Stadium. Ernest Hemingway said of my stint that it was "the dark side of the moon of Walter Mitty."

Nonetheless there were compensations. If briefly, I had actually been thrust into one of the most sacrosanct of worlds.... Whatever the humiliations, if one remained the observer, what one experienced and learned could be set down later. There were things to be said.

Brendan Gill

Happy writers have histories shorter even than happy families. The whole of my professional career can be summed up by saying that I started out at the place where I wanted to be—*The New Yorker* magazine—and with much pleasure and very little labor have remained here ever since. Sometimes, and with reason, I boast of never having done an honest day's work in my life. An honest day's play—oh, that I have accomplished on a thousand occasions, or ten thousand, but work implies a measure of drudgery and fatigue, and these are states as yet unknown to me. With *The New Yorker* serving as my passport and letter of credit, how easy I have found it for almost forty years to rush pell-mell through the world, playing the clown when the spirit of darkness has moved me and colliding with good times at every turn!

Such a confession will no doubt make unwelcome reading to my colleagues, for the fashion among them is to hold that writing is a prolonged and disenchanting misery. A friend of mine, Patrick Kavanaugh, who was the premier poet in Ireland after Yeats, said of the peasantry from which he sprang that they live in the dark cave of the unconscious and they scream when they see the light. They *scream* when they see the light. Now, most *New Yorker* writers share this attribute with Irish peasants. They tend to be lonely molelike creatures, who work in their own portable if not peasant darkness and who seldom utter a sound above a groan. It happens that I am not like that. On the contrary, I am among those who enjoy the light and even, to a certain extent, the limelight—a predilection that has its hazards. Once I was showing off at a cocktail party, and I mentioned some very arcane fact that we had dug up for "Talk of the Town," like that Saint Ambrose was the first person in history reputed to have been able to read without moving his lips. Somebody asked me how I knew that, and I replied grandly, "I know everything." And a pretty girl was there, an Italian model, and she looked up at me with great melting dark eyes and said softly, "Tell me about the Battle of Mukden." I burst out in dismay, "Mukden, Mukden, the Battle of Mukden—!" For, sure enough, I knew nothing whatever about that very important event.

Tom Wolfe

The piece about car customizers in Los Angeles was the first magazine piece I ever wrote. I was totally blocked.... I suddenly realized I'd never written a magazine article before and I just felt I couldn't do it. Well Byron Dobell shamed me into writing down the notes that I had taken in my reporting on the car customizers so that some competent writer could convert them into a magazine piece. I sat down one night and started writing a memorandum to him as fast as I could, just to get the ordeal over with. It became very much like a letter that you would write to a friend in which you're not thinking about style, you're just pouring it all out, and I churned it out all night long, forty typewritten, triple-spaced pages. I turned it in in the morning to Byron at *Esquire,* and then I went home to sleep. About four that afternoon I got a call from him telling me, "Well, we're knocking the 'Dear Byron' off the top of your memo, and we're running the piece." That was a tremendous release for me. I think there are not many editors who would have done that, but *Esquire* at that time was a very experimental magazine.

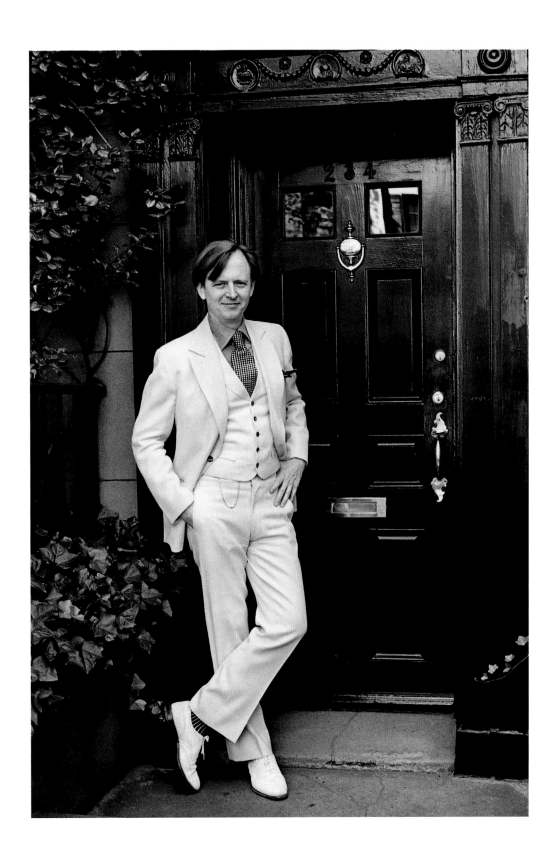

Gloria Steinem

I didn't discover that most people worked from nine to five, had bosses, and got regular paychecks until I was well along in high school, and by that time—as every Jesuit knows—it was too late. My father had two points of pride: he never wore a hat and he never had a job. (That is, for better or worse, he never worked for anyone else.) In the summer, he ran his resort in Michigan, and I saw mostly band men and entertainers, families on vacation (I never wondered vacation from what), and the local farmers, who were the most independent of all. In the winter, we avoided Michigan snows by traveling around the South in a house trailer while my father plied his secondary trade of antiques dealing. This schedule kept me safely out of school until I was twelve, and developed almost no sense of discipline. (There was rarely any reason for going to bed or getting up at a certain hour, and I still find it pretty difficult to think of one.) It also gave me a lot of time to read.

Years of indiscriminate reading left me with a big vocabulary and a fascination for anything in print. I soon developed myopia and a firm belief that people in books were not only more interesting but more *real* than people outside of books. And, of course, authors seemed almost as glamorous and omnipotent as movie stars.

Still, I don't remember telling anyone in high school or college that I wanted to be a writer, or even privately planning it. I didn't write for school literary magazines or newspapers, I think out of some rather pushy conviction that one should write professionally or not at all. My one writerly habit was describing everything I did, no matter how absorbing or how trivial, as if I were standing outside myself and watching. That is, I would get up in the morning and look out the window, all the time thinking, "She slid from the rumpled bed, yawned, and looked out at the pale . . . no, *thin* winter light. It was going to be another one of those days. . . ."

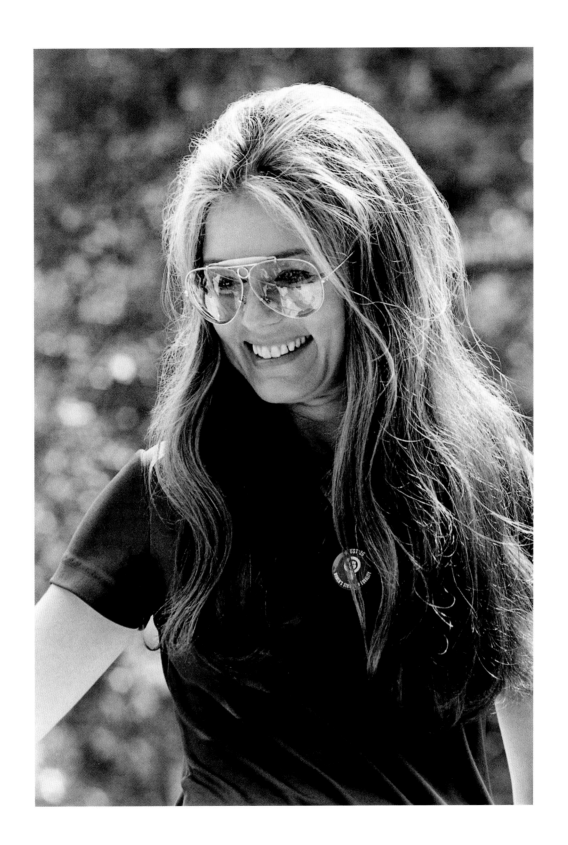

Truman Capote

I guess I was around twelve. The principal of the school I was attending paid a call on my family, and told them that in his opinion, and in the opinion of the faculty, I was "subnormal." He thought it would be sensible, the humane action, to send me to some special school equipped to handle backward brats. Whatever they may have felt privately, my family as a whole took official umbrage, and in an effort to prove I wasn't subnormal, pronto packed me off to a psychiatric study clinic at a university in the East where I had my IQ inspected. I enjoyed it thoroughly and—guess what?— came home a genius, so proclaimed by science. I don't know who was the more appalled: my former teachers, who refused to believe it, or my family, who didn't want to believe it—they'd just hoped to be told I was a nice normal boy. Ha ha! But as for me, I was exceedingly pleased—went around staring at myself in mirrors and sucking in my cheeks and thinking over in my mind, My lad, you and Flaubert—or Maupassant or Mansfield or Proust or Chekhov or Wolfe, whoever was the idol of the moment.

I began writing in fearful earnest—my mind zoomed all night every night, and I don't think I really slept for several years.

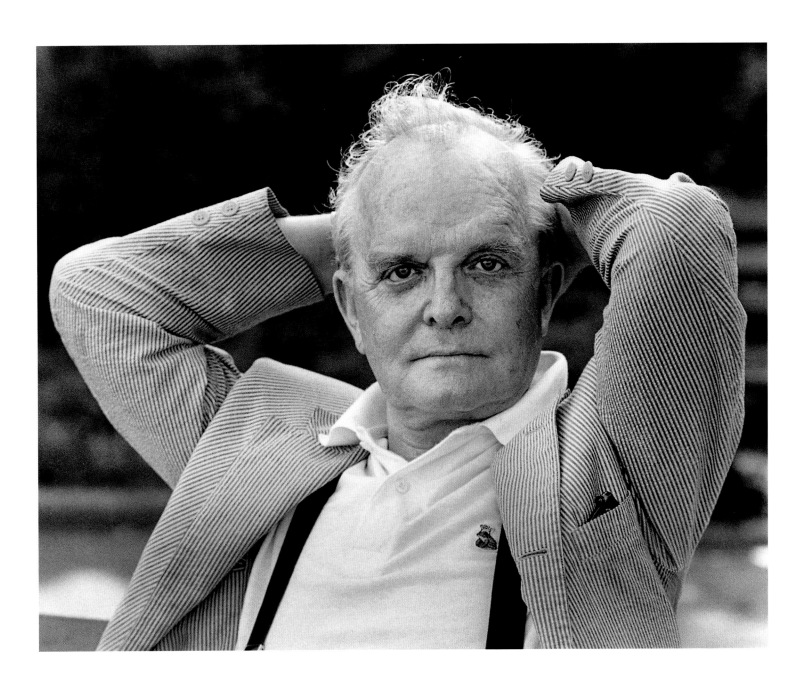

Maya Angelou

I would be a liar, a hypocrite, or a fool—and I'm not any of those—to say that I don't write for the reader. I do. But for the reader who hears, who really will work at it, going behind what I seem to say. So I write for myself and that reader who will pay the dues. There's a phrase in West Africa, in Ghana; it's called "deep talk." For instance, there's a saying: "The trouble for the thief is not how to steal the chief's bugle, but where to blow it." Now, on the face of it, one understands that. But when you really think about it, it takes you deeper. In West Africa they call that "deep talk." I'd like to think I write "deep talk." When you read me, you should be able to say, "Gosh, that's pretty. That's lovely. That's nice. Maybe there's something else? Better read it again." Years ago I read a man named Machado de Assis who wrote a book called *Dom Casmurro: Epitaph of a Small Winner*. Machado de Assis is a South American writer— black mother, Portuguese father—writing in 1865, say. I thought the book was very nice. Then I went back and read the book and said, "Hmm. I didn't realize all that was in that book." Then I read it again, and again, and I came to the conclusion that what Machado de Assis had done for me was almost a trick: he had beckoned me onto the beach to watch a sunset. And I had watched the sunset with pleasure. When I turned around to come back in I found that the tide had come in over my head. That's when I decided to write. I would write so that the reader says, "That's so nice. Oh boy, that's pretty. Let me read that again."

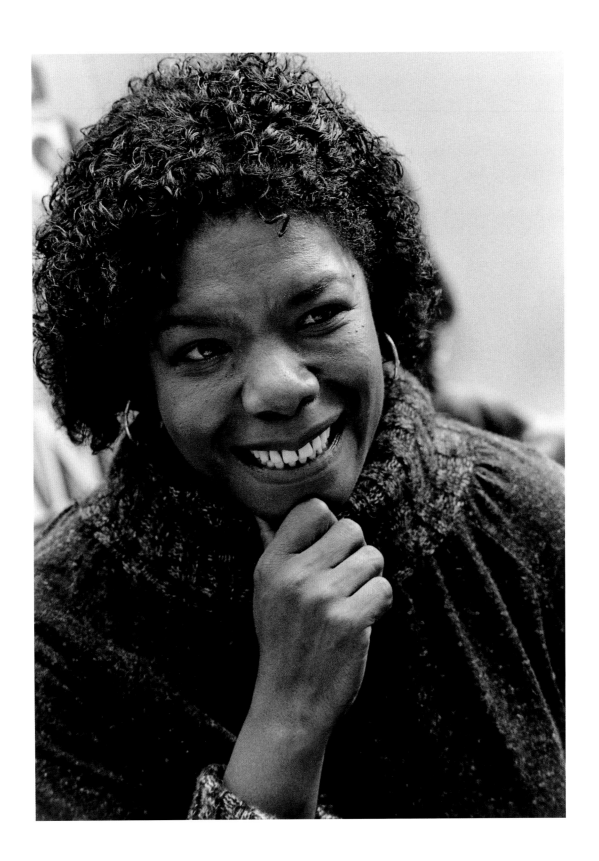

Seymour Britchky

Nothing is more irrelevant to a critic's work than his likes and dislikes, and nothing is more destructive to his subject than the handy collection of rules he carries around in his head where his open mind belongs. It is not a critic's job to love or loathe; it is his job to evaluate, and the standards of evaluation vary from subject to subject—they inhere in the pretensions and objectives of the subjects themselves. We do not criticize *Die Fledermaus* for failing to be *Fidelio,* or a meat loaf because it is not a *pâté en croûte.*

There was a restaurant critic who, when asked his opinion of certain Italian wines, answered that he drank only French wines. We may as well have restaurant writers who are vegetarians, or who eat only kosher food, or who cannot be bothered with fish because of the bones.

And when our critics are not averting their noses from what they did not learn to like at their mothers' knees or on the grand tour, they reserve judgment on what they eat until they have looked it up to see if it was made according to Hoyle. It is something of a burden to New Yorkers in search of a hot meal and a good time to be stuck with critics who cannot enjoy themselves without consulting authority. Some of these critics have never lost touch with their earliest educations, when the correct answers were in the back of the book. Many good restaurants are dismissed by them because their virtues are not in the back of the book. The principal danger of the grammar-school school of critics is their love of joyless restaurants that score high on standard tests.

It is the restaurant critic's responsibility to have a capacity for pleasure that encompasses a motley scene. But the first function of a critic—literary critic, music critic, any kind of critic—is to describe, so that the reader learns about the subject rather than the critic. The purpose of *The Restaurants of New York*—invective, derisions, and lyricisms notwithstanding—is to make the places described seem real to the reader.

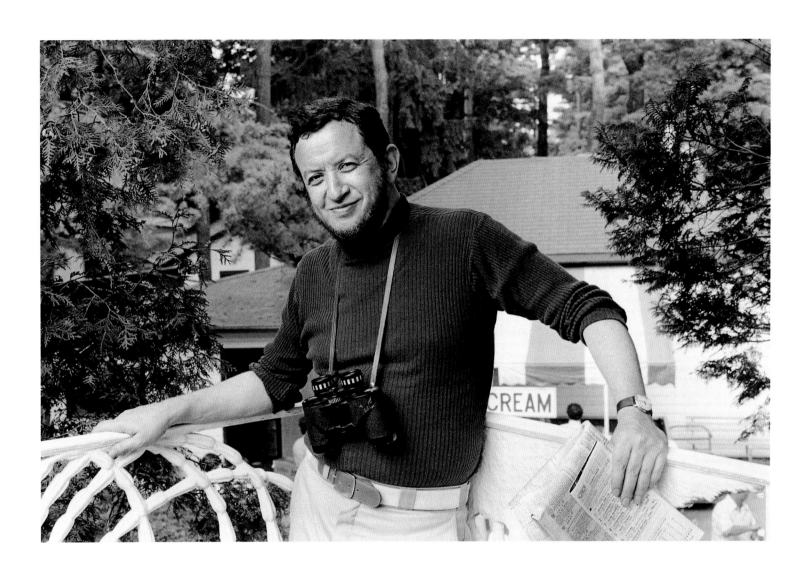

William Styron

I sometimes wake up in a sweat and ask myself, "Why did I become a writer?" It seems like it would be a lesson one would learn around the age of twenty or thereabouts that what you're doing is *confronting the unknown.* There's this blank paper. It's a corridor, it's a white corridor with no resonances, with no shadows, and down you go—*Plunge!*—for several years, trusting to your intuition, to whatever knowledge you've got, whatever ingenuity you can summon. But no one's there to tell you that you might run into a dead end, and there's no way out.... The amount of faith you have to have in yourself is considerable—especially in this country where the critical standards are so vicious. There is a terrible thing in American writing which calls you to task, asks you to exceed yourself every time. You can't sit down and just say, "Well, today I'm going to write something else, and it will have its own level, and it's not going to be the *Divine Comedy* or *War and Peace.* It's going to be something else."

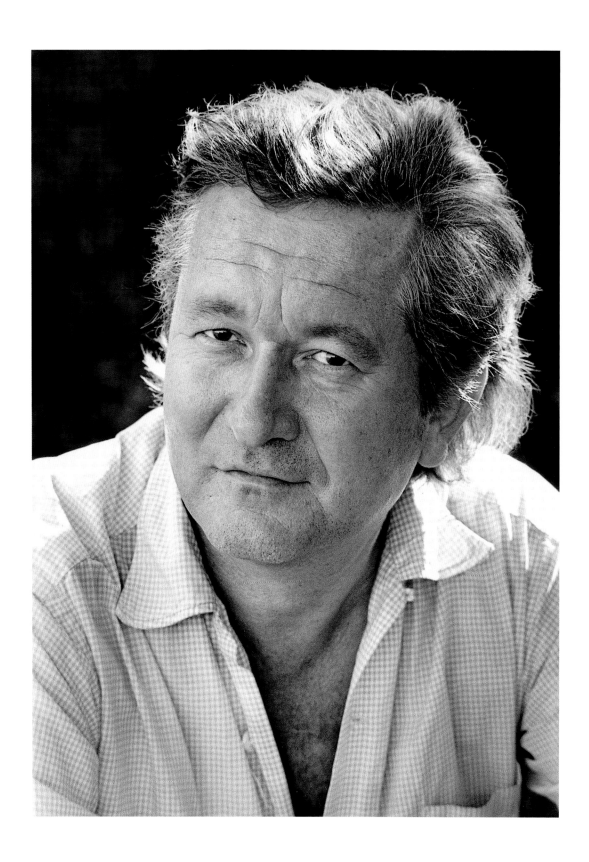

Jorge Luis Borges

My memory carries me back to a certain evening some sixty years ago, to my father's library in Buenos Aires. I see him; I see the gaslight; I could place my hand on the shelves. I know exactly where to find Burton's *Arabian Nights* and Prescott's *Conquest of Peru,* though the library exists no longer. I go back to that already ancient South American evening, and I see my father. I am seeing him at this moment; and I hear his voice saying words that I understood not, but yet I felt. Those words came from Keats, from his "Ode to a Nightingale." I have reread them ever so many times...I thought I knew all about words, all about language (when one is a child, one feels one knows many things), but those words came as a revelation to me. Of course I did not understand them. How could I understand those lines about birds—about animals—being somehow eternal, timeless, because they live in the present? We are mortal because we live in the past and in the future—because we remember a time when we did not exist, and foresee a time when we shall be dead. Those verses came to me through their music. I had thought of language as being a way of saying things, of uttering complaints, of saying that one was glad, or sad, and so on. Yet when I heard those lines (and I have been hearing them, in a sense, ever since), I knew that language could also be a music and a passion. And thus was poetry revealed to me.

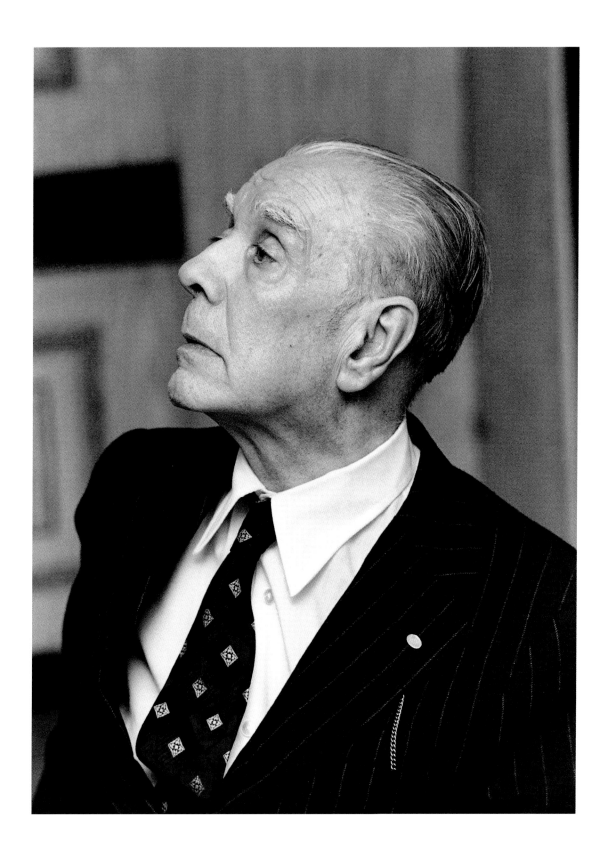

Christopher Isherwood

On turning a real person into a fictional character:

It happens through the process of thinking of them in their eternal, magic, symbolic aspects: It's rather the way you feel when you fall in love with somebody and that person ceases to be just another face in the crowd. The difference is that in art, almost by definition, everybody is quite extraordinary if only you can see them as such. When you're writing a book, you ask yourself: What is it that so intrigues me about this person—be it good or bad, that's neither here nor there, art knows nothing of such words. Having discovered what it is you really consider to be the essence of the interest you feel in this person, you then set about heightening it. The individuals themselves aren't quite up to this vision you have of them. Therefore you start trying to create a fiction-character that is quintessentially what you see as interesting in the individual, without all the contradictions that are inseparable from a human being, aspects that don't seem exciting or marvelous or beautiful. The last thing you're trying to do is get an overall picture of somebody, since then you end up with nothing.

SANTA MONICA, CALIFORNIA 1977

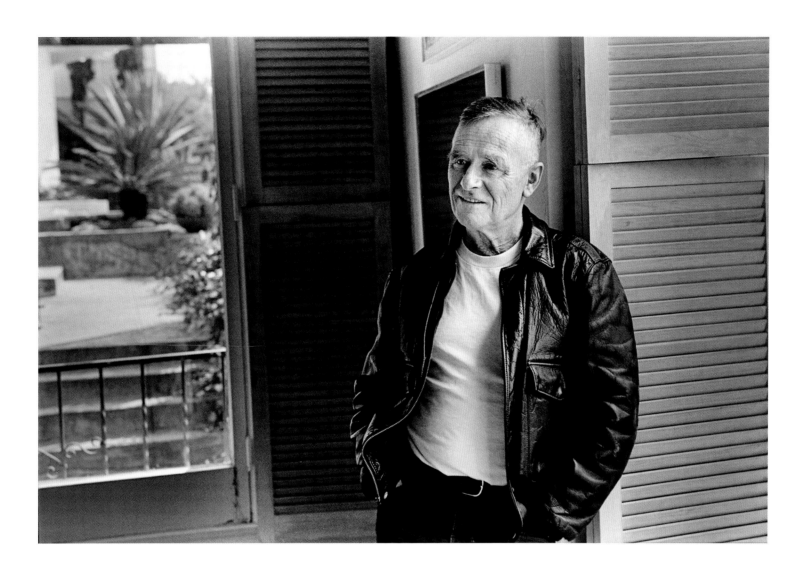

Tennessee Williams

A lot of people think I wrote *The Glass Menagerie* while I was employed at MGM. This is not true. I didn't write for films for more than three weeks. I was given the assignment of writing a film for Lana Turner—*Marriage Is a Private Affair,* it was called. The producer happened to have an attachment of a romantic nature to the lady, but he was realistic about her abilities as an actress. He would keep saying, "Oh, this is beautiful stuff, Mr. Williams, but she can't say it. She doesn't know how to read it. Now, why don't you just forget all about this Hollywood business, this screenwriting business, and just go out to Santa Monica. We're obliged to pay you two hundred forty dollars a week, so just come in and collect your check, go back out to Santa Monica Beach, and do your own work," he said, "because your own work is good." I saved enough money so that I could spend a summer free of harassment, and free of occupation, in Provincetown. I wrote *The Glass Menagerie* there, and also in the law school dormitory at Harvard, because I had a friend there.

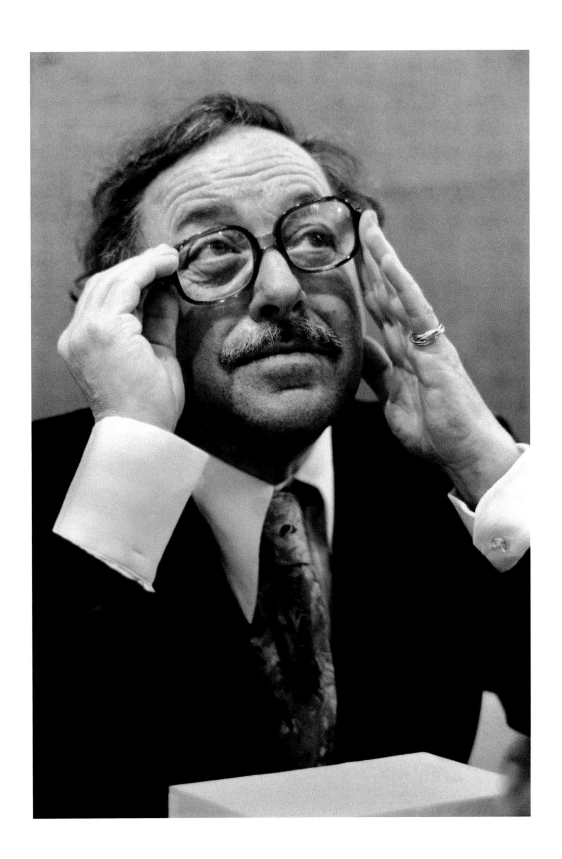

Lanford Wilson

There's a speech in *Angels Fall* where Zappy, the tennis player, talks about when he was eleven and skinny. He walks by these two guys playing on a tennis court. He watches them, and as a joke they throw him a ball and a racket, and he tosses the ball up and whams it across the net. There's no one over there, but that was an ace, man. And Zappy says, "I knew I was a tennis player. That's what I do."

Well, that's what happened to me. I was going to be a graphic artist. I was writing stories while I was working in this ad agency. I thought of a story and I said, "Oh, that's more of a play than it is a narrative," and I started writing it as a play, and by page two I decided, I'm a playwright. Clear as day. I had a *real* talent for writing dialogue, for getting the essence of a character. I knew it by page two. And doors just flew open all the way down the hall! There was no one over there, but that was an ace.

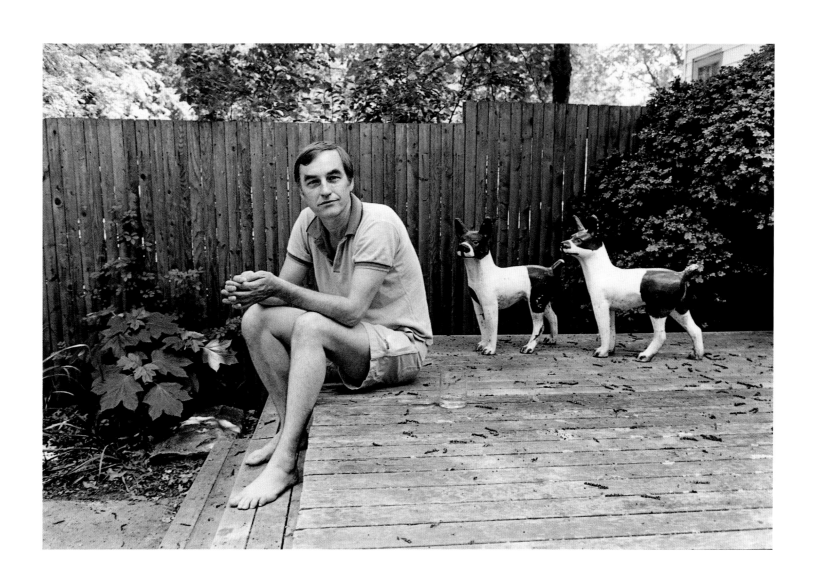

Gwendolyn Brooks

When my husband and I (my husband doesn't see everything the way I do) were in Ghana we would have some fierce arguments (he calls them discussions). Once we were walking down a road and we saw a little Ghanaian boy. He was running and happy in the happy sunshine. My husband made a comment springing from an argument we had had the night before that lasted until four in the morning. He said, "Now look, see that little boy. That is a perfect picture of happy youth. So if you were writing a poem about him, why couldn't you just let it go at that? Write a poem about running boy-happy, happy-running boy?" That's the kind of poem he said he would write if he were writing about this boy. He would just see him not as a black boy but as youth-happy. So I said if you wrote exhaustively about running boy and you noticed that the boy was black, you would have to go further than a celebration of blissful youth. You just might consider that when a black boy runs, maybe not in Ghana, but perhaps in the Chicago South Side, you'd have to remember a certain friend of my daughter's in high school—beautiful boy, so smart, one of the honor students, and just an all-around fine young fellow. He was running down an alley with a friend of his, just running and a policeman said "Halt!" And before he could slow up his steps, he just shot him. Now that happens all the time in Chicago. There was all that promise in a little crumpled heap. Dead forever. So I would have to think about that in a poem about a running boy.

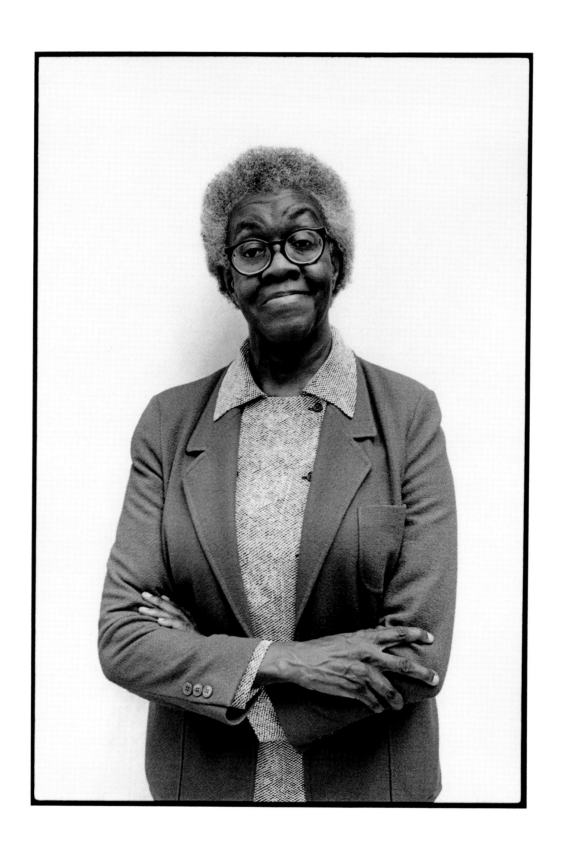

William Shawn

Many magazines have stopped thinking about themselves as publications designed to enlighten and entertain readers and have begun to think of themselves as advertising mediums; others, the pseudo magazines, instead of following some natural editorial bent, have adopted a "formula" expressly devised to attract and frame advertising; some magazines have devoted more attention to "projecting an image" of what they want to appear to be than they have to considering what they really are; others, instead of contributing whatever they themselves might contribute to the cultural life of the country, have been exploiting what is termed the cultural boom.... In the magazine field, as in so many other fields today, the lines have become blurred—lines between the real thing and the bogus, between the spontaneous and the calculated, between substance and razzle-dazzle, between something that is done because it is worth doing and something that is done because it will sell.

There is nothing we [at *The New Yorker*] would rather do than enlighten and entertain our readers. On the other hand *The New Yorker* does not try to guess what its readers want, and does not try to find out what they want. In the realm of literature, of art, of creative journalism, to attempt to give readers what they "want" is, circularly, to give them what they already know about and have already had, and thus to give them nothing. People who are creative are eager to strike out into new territory and to see, discover, and say what has not been seen, discovered, or said before. The writers and artists and editors of *The New Yorker* simply go where their own talent, imagination, energy, curiosity, and conscience take them.

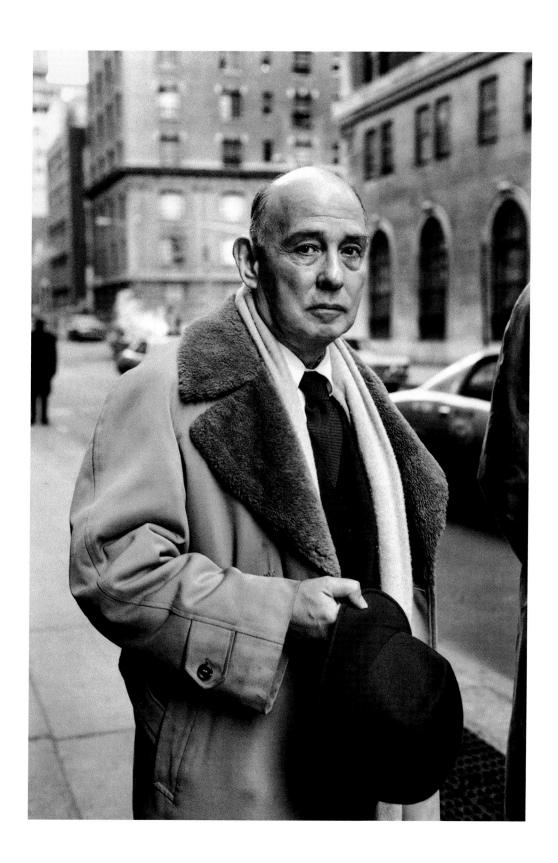

James Salter

There is no situation like the open road, and seeing things completely afresh. I'm used to traveling. It's not a question of meeting or seeing new faces particularly, or hearing new stories, but of looking at life in a different way. It's the curtain coming up on another act.

I'm not the first person who feels that it's the writer's true occupation to travel. In a certain sense, a writer is an exile, an outsider, always reporting on things, and it is part of his life to keep on the move. Travel is natural.... One thing I saw in England long ago struck me and has always stayed with me. I was going to visit someone in a little village, walking from the railway station across the fields, and I saw an old man, perhaps in his seventies, with a pack on his back. He looked to be a vagabond, dignified, somewhat threadbare, marching along with his staff. A dog trotted at his heels. It was an image I thought should be the final one of a life. Traveling on.

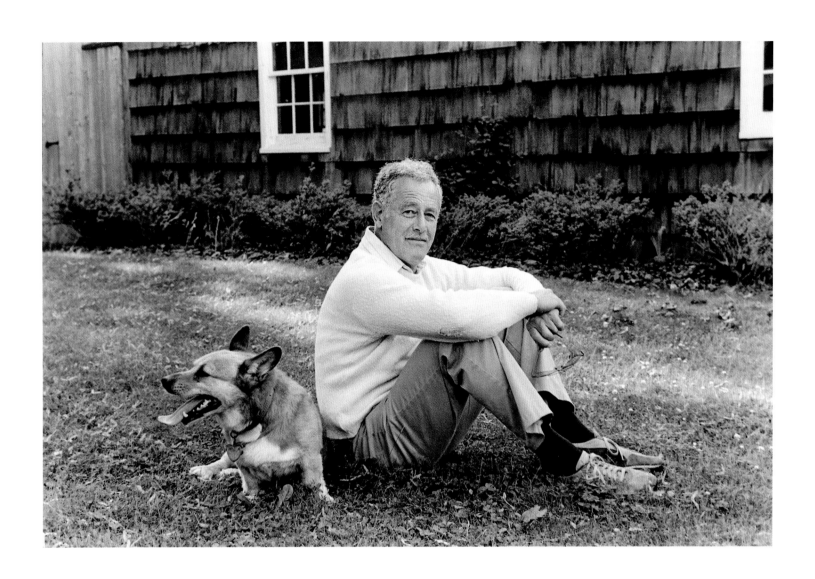

Joseph Brodsky

For the poet the credo or doctrine is not the point of arrival but is, on the contrary, the point of departure for the metaphysical journey. For instance, you write a poem about the crucifixion. You have decided to go ten stanzas—and yet it's the third stanza and you've already dealt with the crucifixion. You have to go beyond that and add something—to develop it into something which is not there yet. Basically what I'm saying is that the poetic notion of infinity is far greater, and it's almost self-propelled by the form. Once in a conversation with Tony Hecht at Breadloaf we were talking about the usage of the Bible, and he said, "Joseph, wouldn't you agree that what a poet does is to try to make more sense out of these things?" And that's what it is. . . . In the works of the better poets you get the sensation that they're not talking to people anymore, or to some seraphical creature. What they're doing is simply talking back to the language itself—as beauty, sensuality, wisdom, irony—those aspects of language of which the poet is a clear mirror. Poetry is not an art or a branch of art, it's something more. If what distinguishes us from other species is speech, then poetry, which is the supreme linguistic operation, is our anthropological, indeed genetic, goal. Anyone who regards poetry as an entertainment, as a "read," commits an anthropological crime, in the first place, against himself.

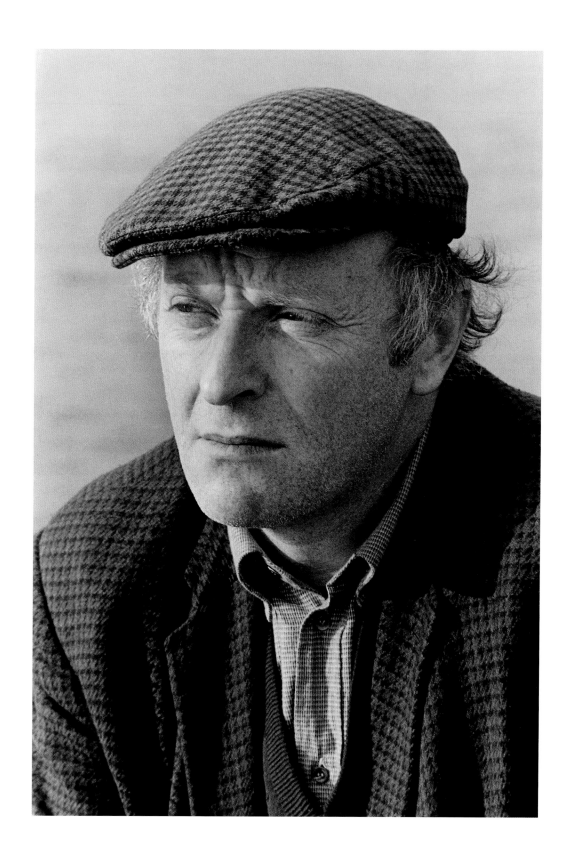

Susan Sontag

Writing is a mysterious activity. One has to be at different stages of conception and execution, in a state of extreme alertness and consciousness and in a state of great naïveté and ignorance. Although this is probably true of the practice of any art, it may be more true of writing because the writer—unlike the painter or composer—works in a medium that one employs all the time, throughout one's waking life. Kafka said: "Conversation takes the importance, the seriousness, the truth out of everything I think." I would guess that most writers are suspicious of conversation, of what goes out in the ordinary uses of language. People deal with this in different ways. Some hardly talk at all. Others play games of concealment and avowal.... There is only so much revealing one can do. For every self-revelation, there has to be a self-concealment. A lifelong commitment to writing involves a balancing of these incompatible needs. But I do think that the model of writing as self-expression is too crude. If I thought that what I'm doing when I write is expressing myself, I'd junk the typewriter. Writing is a much more complicated activity than that.

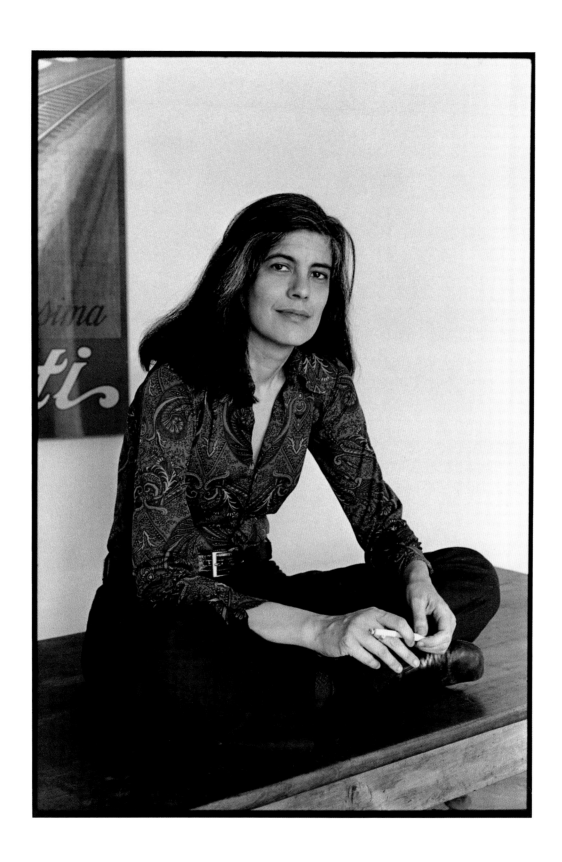

Robert Stone

It was a rereading of *The Great Gatsby* that made me think about writing a novel. I was living on St. Mark's Place in New York; it was a different world in those days. I was in my twenties. I decided I knew a few meanings; I understood patterns in life. I figured, I can't sell this understanding, or smoke it, so I will write a novel. I then started to write *A Hall of Mirrors*. It must have taken me six years, a dreadful amount of time.

A Hall of Mirrors was something I shattered my youth against. All my youth went into it. I put everything I knew into that book. It was written through years of dramatic change, not only for me, but for the country. It covers the sixties from the Kennedy assassination through the civil rights movement to the beginning of acid, the hippies, the war...

One way or another, it all went into the book. And of course it all went very slowly because once my Stegner Fellowship was over, my wife, Janice, and I had to take turns working. I'd work for twenty weeks and then be on unemployment for twenty weeks and so on. So it took me a long, long time to finish it.

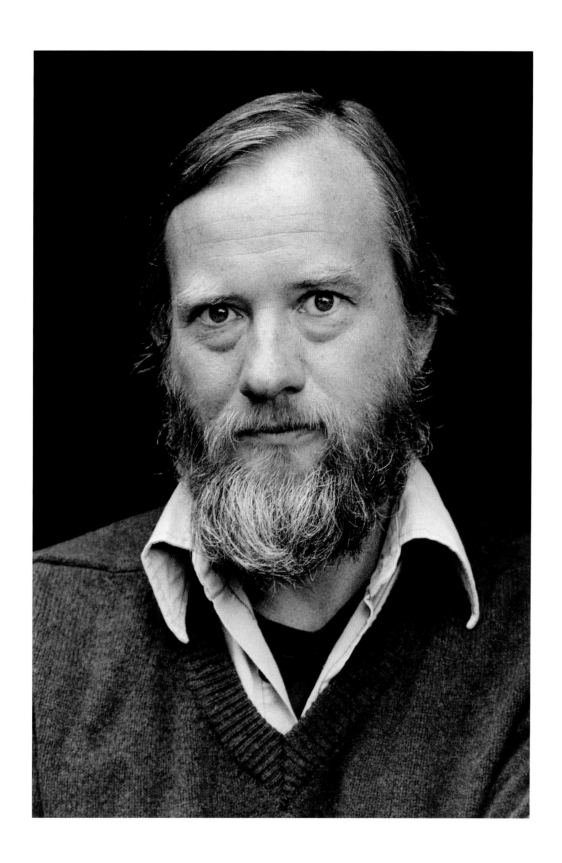

John Ashbery

I often put into my poems things that I have overheard people say, on the street for instance. Suddenly something fixes itself in the flow that is going on around one and seems to have a significance...there is an example of that in this poem, "What Is Poetry?" In a bookstore I overheard a boy saying to a girl this last line: "It might give us—what?—some flowers soon?" I have no idea what the context was, but it suddenly seemed the way to end my poem. I am a believer in fortuitous accidents. The ending of my poem "Clepsydra," the last two lines, came from a notebook that I kept a number of years before, during my first trip to Italy. I actually wrote some poems while I was traveling, which I don't usually do, but I was very excited by my first visit there. So years later, when I was trying to end "Clepsydra" and getting very nervous, I happened to open that notebook and found these two lines that I had completely forgotten about: "while morning is still and before the body / Is changed by the faces of evening." They were just what I needed at that time. But it really doesn't matter so much what the individual thing is. Many times I will jot down ideas and phrases, and then when I am ready to write I can't find them. But it doesn't make any difference, because whatever comes along at that time will have the same quality. Whatever was there was replaceable. In fact, often in revising I will remove the idea that was the original stimulus. I think I am more interested in the movement among ideas than in the ideas themselves, the way one goes from one point to another rather than the destination or the origin.

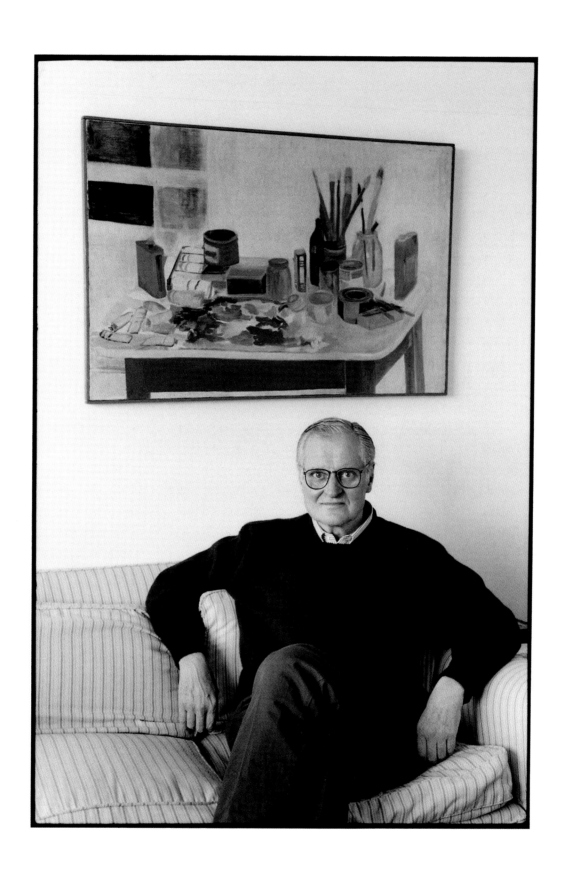

Robert Penn Warren

[I wrote an essay in 1930] about the Negro in the South, and it was a defense of segregation.... I wrote it at Oxford at about the same time I began writing fiction. The two things were tied together—the look back home from a long distance. I remember the jangle and wrangle of writing the essay and some kind of discomfort in it, some sense of evasion, I guess, in writing it, in contrast with the free feeling of writing the novelette *Prime Leaf,* the sense of seeing something fresh, the holiday sense plus some stirring up of something inside yourself. In the essay, I reckon, I was trying to prove something, and in the novelette trying to find out something, see something, feel something—exist.... In a little while I realized I simply couldn't have written that essay again. I guess trying to write fiction made me realize that. If you are seriously trying to write fiction you can't allow yourself as much evasion as in trying to write essays.

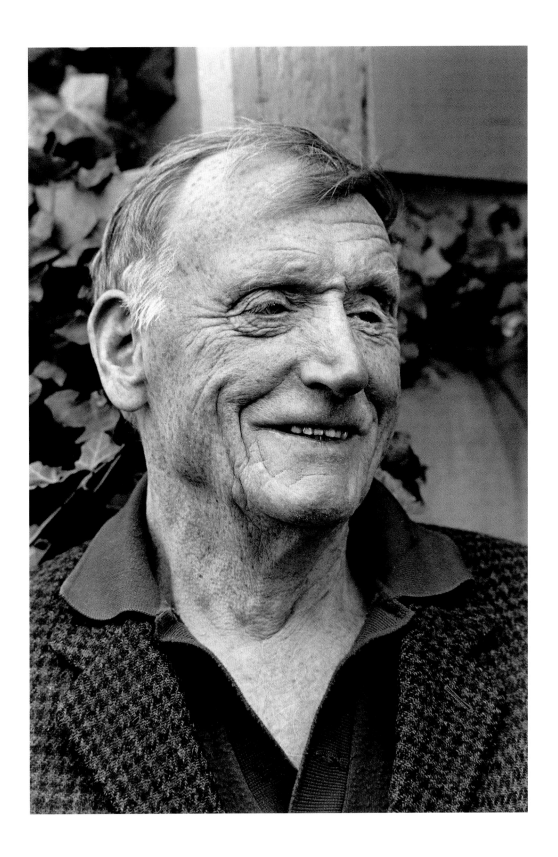

James Baldwin

When I moved out from America, I began to see it from a different perspective.... I can see now what happened to so many people who had perished around me and I could see that it was a political fact, a political disaster, and that I, myself, was in any case a political target; and menaced by forces which I had not seen as clearly when I was in America.

I also realized that to try to be a writer (which involves, after all, disturbing the peace) was political, whether one liked it or not; because if one is doing anything at all, one is trying to change the consciousness of other people. You're trying also to change your own consciousness. You have to use your consciousness, you have to trust it to the extent—enough to begin to *talk;* and you talk with the intention of beginning a ferment, beginning a disturbance in someone else's mind so that he sees the situation...

The poet or the revolutionary is there to articulate the necessity, but until the people themselves apprehend it, nothing can happen.... Perhaps it can't be done without the poet, but it certainly can't be done without the people. The poet and the people get on generally very badly, and yet they need each other. The poet knows it sooner than the people do. The people usually know it after the poet is dead; but that's all right. The point is to get your work done, and your work is to change the world.

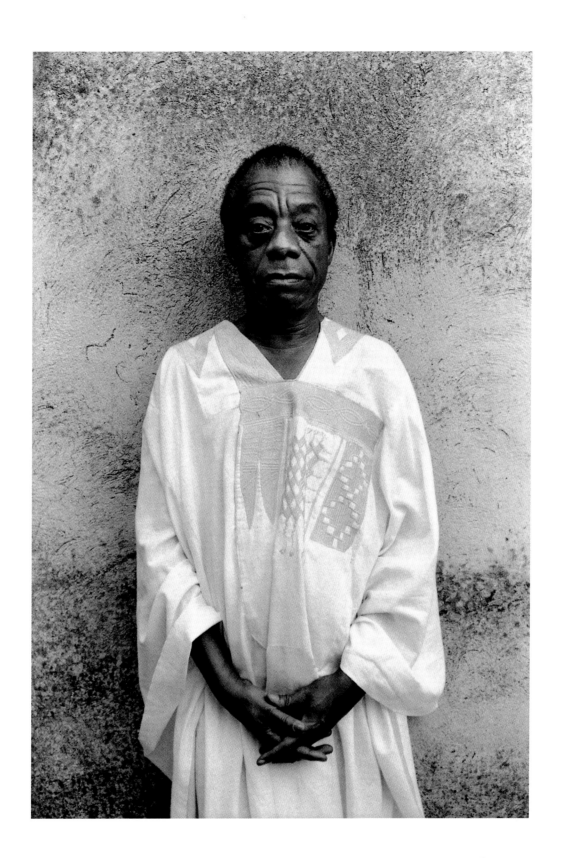

S. J. Perelman

On how many drafts he writes of each piece:

Thirty-seven. I once tried doing thirty-three, but something was lacking, a certain—
how shall I say?—*je ne sais quoi.* On another occasion, I tried forty-two versions, but
the final effect was too lapidary.

On having worked in Hollywood:

A dreary industrial town controlled by hoodlums of enormous wealth, the ethical
sense of a pack of jackals, and taste so degraded that it befouled everything it
touched. . . . When I watched the fashionable film colony arriving at some premiere at
Grauman's Egyptian, I fully expected God in his wrath to obliterate the whole
shebang. It was—if you'll allow me to use a hopelessly inexpressive word—*dégoûtant.*

I regard my comic writing as serious. For years, I have been approached almost hourly
by damp people with foreheads like Rocky Ford melons who urge me to knock off my
frivolous career and get started on that novel I'm burning to write. I have no earthly
intention of doing any such thing. I don't believe in the importance of scale; to me the
muralist is no more valid than the miniature painter. In this very large country, where
size is all and where Thomas Wolfe outranks Robert Benchley, I am content to stitch
away at my embroidery hoop. I think the form I work can have its own distinction,
and I would like to surpass what I have done in it.

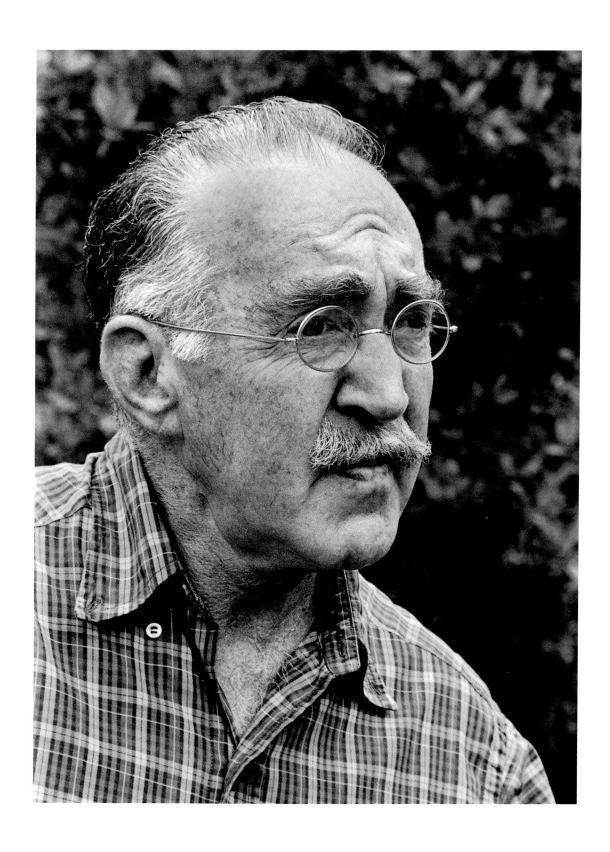

Harold Bloom

I was preadolescent, ten or eleven years old. I still remember the extraordinary delight, the extraordinary force that Crane and Blake brought to me (in particular Blake's rhetoric in the longer poems) though I had no notion what they were about. I picked up a copy of the *Collected Poems* of Hart Crane in the Bronx Library. I still remember when I lit upon the page with the extraordinary trope, "Thou steeled Cognizance whose leap commits / The agile precincts of the lark's return." I was just swept away by it, the Marlovian rhetoric. I still have the flavor of that book in me. Indeed it's the first book I ever owned. I begged my oldest sister to give it to me, and I still have the black and gold edition she gave me for my birthday back in 1942. . . . Why is it you can have that extraordinary experience (preadolescent in my case as in so many other cases) of falling violently in love with great poetry . . . where you are moved by its power before you comprehend it?

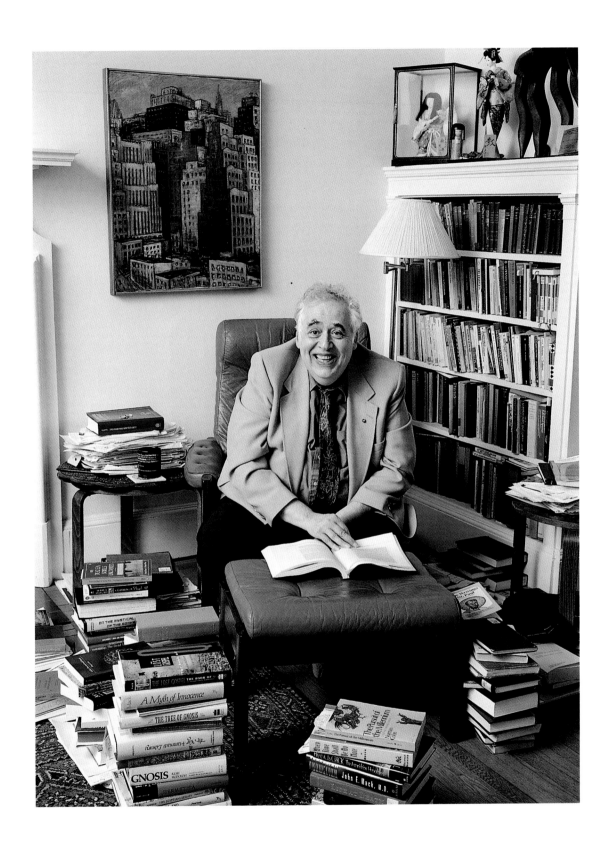

Norman Mailer

A writer, no matter how great, is never altogether great; a small part of him is seriously flawed. Tolstoy evaded the depths that Dostoyevsky opened; in turn, Dostoyevsky, lacking Tolstoy's majestic sense of the proportion of things, fled proportion and explored hysteria. A writer is recognized as great when his work is done, but while he is writing, he rarely feels great. He is more likely to live with the anxiety of "Can I do it? Should I let up? Will dread overwhelm me if I explore too far? Or depression deaden me if I do not push on? Can I even do it?" As he writes, the writer is reshaping his character. He is a better man and he is worse, once he has finished a book. Potentialities in him have been developed, other talents have been sacrificed. He has made choices on his route and the choices have shaped him. By this understanding, a genius is a man of large talent who has made many good choices and a few astounding ones. He has had the wit to discipline his cowardice and he has had the courage to be bold where others might cry insanity. Yet no matter how large his genius, we can be certain of one thing—he could have been even greater.

William Gaddis

"All's brave that youth mounts and folly guides," as we're told in *As You Like It. The Recognitions* started as a short piece of work, quite undirected, but based on the Faust story. Then as I got into the idea of forgery, the entire concept of forgery became—I wouldn't say an obsession—but a central part of everything I thought and saw; so the book expanded from simply the central character of the forger to forgery, falsification and cheapening of values and what have you, everywhere. Looking at it now with its various faults, I suppose excess would be the main charge. I remember Clive Bell looking back on his small fine book, *Art,* thirty-five years after it was published in 1913, and listing its faults, finding it too confident and aggressive, even too optimistic—I was never accused of that!—but still feeling, as he said, a little envious of the adventurous young man who wrote it.

Paul Theroux

People who have no idea who they are talking to have told me that they love Paul Theroux's stories; yet I can see they aren't impressed with me. Of course! Other people have told me to my face that they dislike my stories, but that I am a good sort. Why is this? As a person I am hurt and incomplete. My stories are the rest of me. I inhabit every sentence I write! I tear them out of my heart!

After a long, fruitful, and friendly time in London (1971–1990), I came to realize that I hated literary society for the very reasons I had once liked it: the shabby glamour, the talk, the drink, the companionship, the ambition, the business, and the belief: You are your stories. I protested, *No, no—my stories are better than me,* and went away.

Conspicuousness is not for me. My pleasure is that of a specter. I am calmest in remote places, haunting people who have no need of books and no idea what I do. I understand magicianship, murder, guilt, and motherhood: I also understand the demented people who late at night telephone strangers and whisper provocative words to them. Sometimes I feel like someone who has committed the perfect crime, an offender on the loose, who will never be caught. Please don't follow me, or ask me what went wrong. Please don't watch me eat.

My secret is safe. No one ever sees me write. One of the triumphs of fiction is that it is created in the dark. It leaves my house in a plain wrapper, with no bloodstains. Unlike me, my stories are whole and indestructible. In a reversal of the natural order, I am the shadow, my fiction is the substance. If my books are buried by time they can be dug up. The most powerful of the Chinese emperors, Qin Shi Huangdi—who tried—could not make books vanish.

Pretty soon I will be gone, and afterwards when people say, *He is his stories,* the statement will be true.

William Maxwell

True autobiography is very different from anything I've ever written. Edmund Gosse's *Father and Son* has a candor which comes from the intention of the writer to hand over his life. If the writer is really candid then it's good autobiography, and if he's not, then it's nothing at all. I don't feel that my stories, though they may appear to be autobiographical, represent an intention to hand over the whole of my life. They are fragments in which I am a character along with all the others. They're written from a considerable distance. I never feel exposed by them in any way.

As I get older I put more trust in what happened, which has a profound meaning if you can get at it. But what you invent is important too. Flaubert said that whatever you invent is true, even though you may not understand what the truth of it is.

When I reread *The Folded Leaf,* the parts I invented seem so real to me that I have quite a lot of trouble convincing myself they never actually happened.

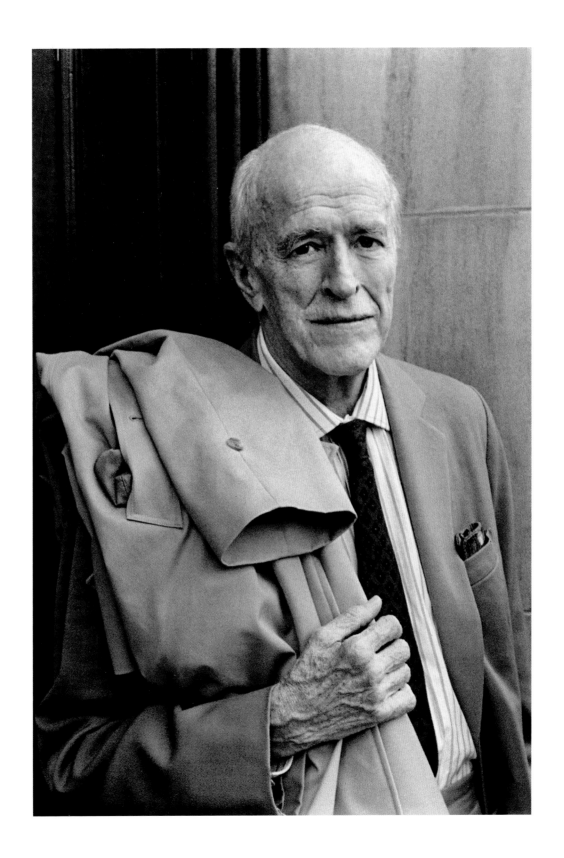

Lorrie Moore

My parents were members of an amateur operetta club, which put on musicals as well as straight plays, and from a very early age I was brought to watch the rehearsals on Sunday afternoons (the actual evening productions were past my bedtime). And when I think about it now, those Sunday afternoons of watching grown-ups put on plays— watching them fall in and out of character, or burst into song or laughter—were probably the most enchanted and culturally formative moments of my childhood.... I would sit there, fantastically engaged—gripped, really—while someone who was ordinarily the postman, say, or the office manager at GE, came out and danced something wild from *Pajama Game*. And watching it all—from the time I was about three or four—I became if not stagestruck, then theaterstruck, or artstruck. Somethingstruck. For my parents it may all have been a cheap form of babysitting, I don't know, but it was enthralling for me. Looking back I now suspect that bit of early theatergoing is still at the heart of what I think is interesting and powerful narratively. I suspect that love of the theater—and that condition, however thrilling, of forever being in the audience—is part of the pulse of everything I've written.

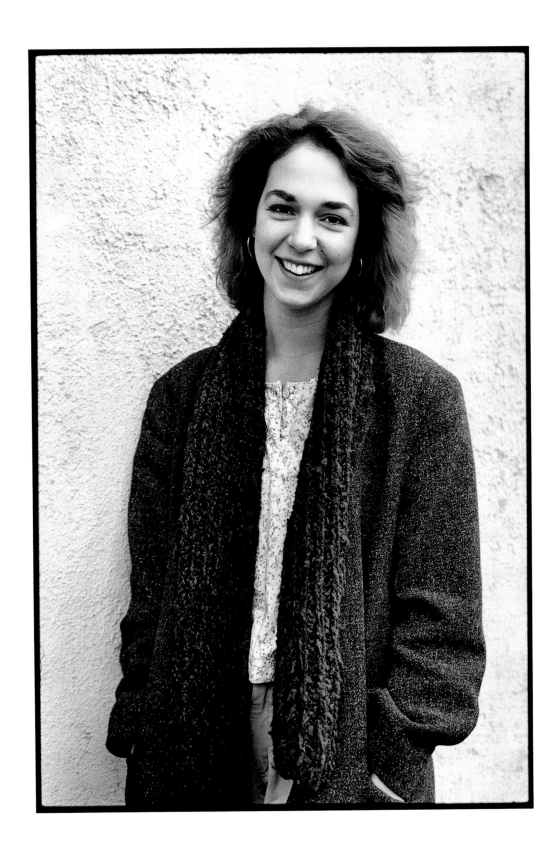

Kurt Vonnegut

So much of what happens in storytelling is mechanical, has to do with the technical problems of how to make a story work. Cowboy stories and policeman stories end in shoot-outs, for example, because shoot-outs are the most reliable mechanisms for making such stories end. There is nothing like death to say what is always such an artificial thing to say: "The end." I try to keep deep love out of my stories because, once that particular subject comes up, it is almost impossible to talk about anything else. Readers don't want to hear about anything else. They go gaga about love. If a lover in a story wins his true love, that's the end of the tale, even if World War III is about to begin, and the sky is black with flying saucers.

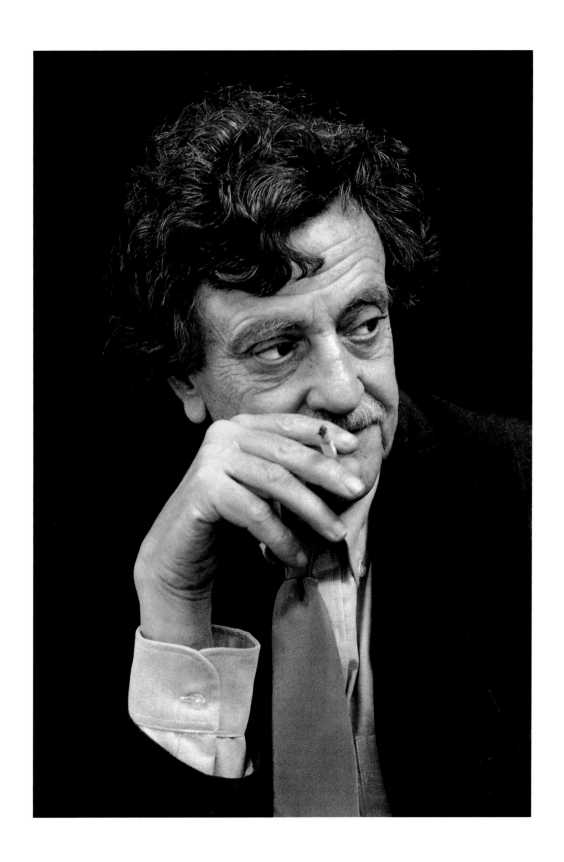

Tom Stoppard

I like dialogue which is slightly more brittle than life. I have always admired and wished to write one of those 1940s film scripts where every line is written with a sharpness and economy which is frankly artificial. Peter Wood, the director with whom I've worked for sixteen years, sometimes feels obliged to find a humanity, perhaps a romantic ambiguity, in scenes which are not written like that but which, I hope, contain the possibility. I like surface gloss, but it's all too easy to get that right for the first night, only to find that *that* was the best performance of the play; from then on the gloss starts cracking apart. The ideal is to make the groundwork so deep and solid that the actors are continually discovering new possibilities under the surface, so that the best performance turns out to be the last one.

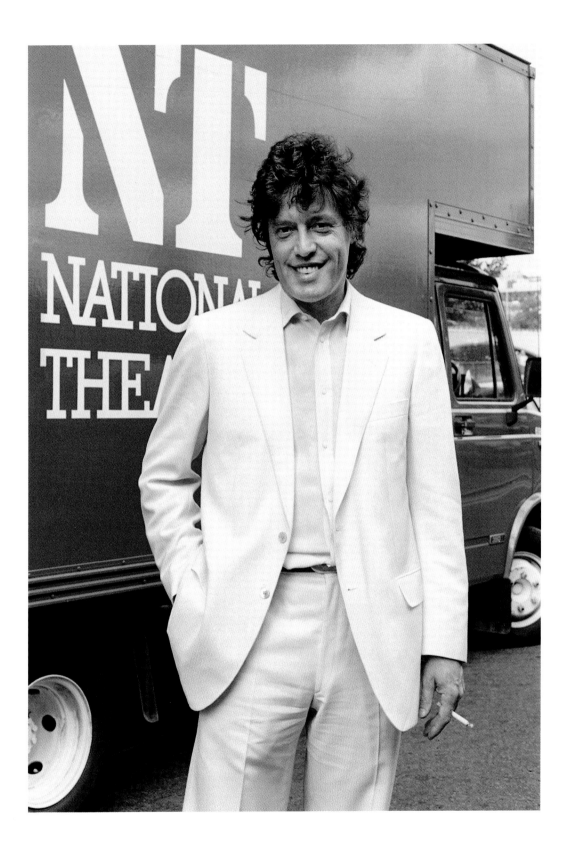

Günter Grass

Born in 1927, in Germany, I was twelve years old when the war started and seventeen years old when it was over. I am overloaded with this German past. I'm not the only one; there are other authors who feel this. If I had been a Swedish or a Swiss author I might have played around much more, told a few jokes and all that. That hasn't been possible; given my background, I have had no other choice. In the fifties and the sixties, the Adenauer period, politicians didn't like to speak about the past, or if they did speak about it, they made it out to be a demonic period in our history when devils had betrayed the pitiful, helpless German people. They told bloody lies. It has been very important to tell the younger generation how it really happened, that it happened in daylight, and very slowly and methodically. At that time, anyone could have looked and seen what was going on. One of the best things we have now is that we can talk about the Nazi period. And postwar literature played an important part in bringing that about.

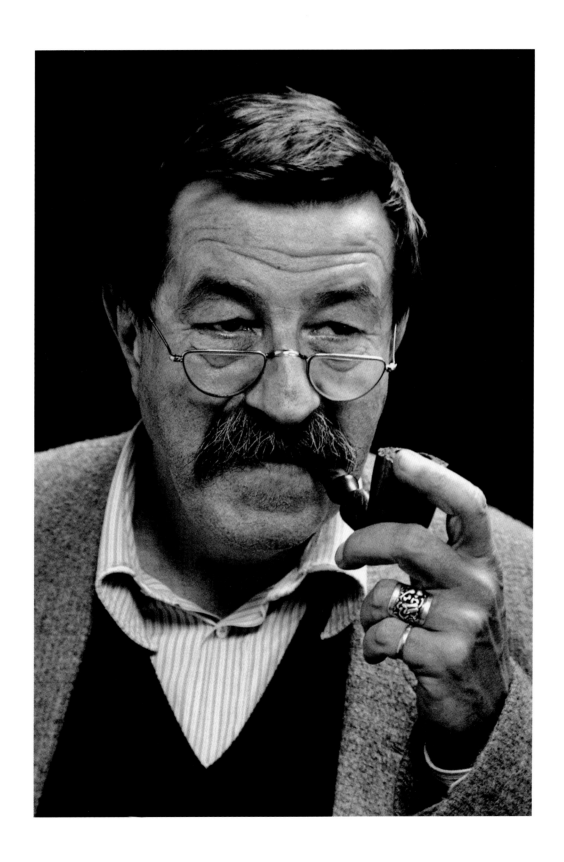

Beryl Bainbridge

I thought I'd walk down the street and everybody would know I had written a book. But nobody took any notice of my first two novels, and I stopped writing. I felt uneasy for about three years.

Then, one day my son was playing with another little boy, and his mother rang asking for him. As we spoke she said, "I recognize your voice. What is your name?" I gave my married name, Beryl Davies, and she said, "What was your name before?" When I told her Bainbridge, she said, "I've read your two books; they are pretty awful, but have you got anything else?" And that was Anna Haycraft, Colin Haycraft's wife, who became my editor at Duckworth for about six years.

Anna and Colin operated in an old piano factory, and they even employed me to wrap up my own books. But Duckworth didn't make any money—ever—because Colin was not bothered about it. . . . But the Haycrafts knew everybody who was anybody in the literary world, and they used to give parties to which they all came. Being at Duckworth meant that you met all these interesting people, and I had a good memory, having been in the theater, and I always remembered people's names and things. I was fortunate in that respect, because Duckworth never had a publicity department—the idea of it would have made them laugh—and you did your own publicity. . . .

Colin was also very good for novelists, being academic and rigorous about clarity. He trained his writers. And Anna would say, "stick to what you know, to your own life," which was what at the time I was interested in anyway, except that there had to be a plot.

Then, six years ago, Colin died and in a terrible sort of way it released me; it enabled me to have confidence enough to do research and write about history or about those subjects which he knew so much better than I. I would never have had the nerve to do it if he was still alive, because he was so learned and clever. I was conscious that I had to do something else, as I had used up everything I knew about my own life. So I went off to write novels based on historical facts.

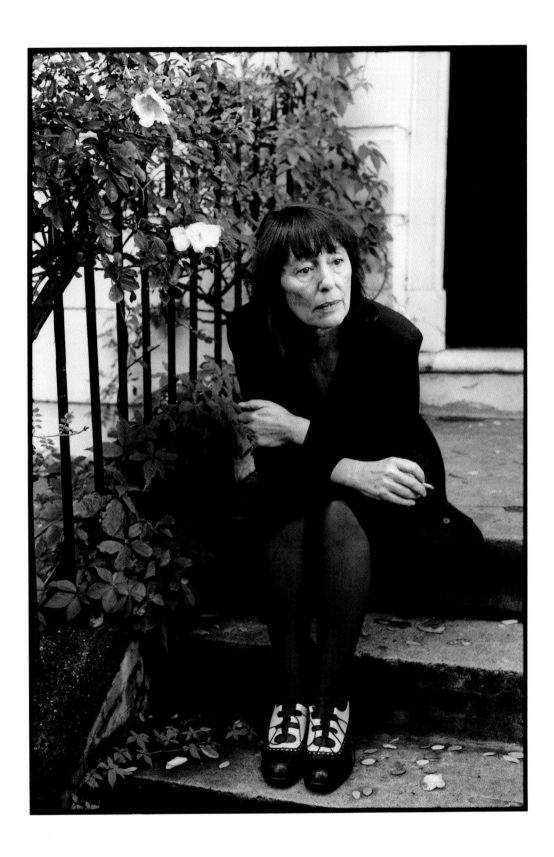

Peter Matthiessen

The inception of *Far Tortuga* was a nonfiction piece for *The New Yorker* about a Grand Cayman turtle-fishing schooner still under sail off the reefs of Nicaragua. On that voyage I was struck by the simplicity of those lives, the spareness—the bareness—of their ship and gear. Everything was faded and worn bare. In those heavy trade winds, on unmarked reefs, they had no life jackets and the radio did not work. Somehow this simplicity was very moving, and I knew from the first day at sea that I would do a novel.... The prose had to reflect the spareness of those lives. I began by throwing out most of the furniture of novel writing, from simile and complex sentences right down to the *he said* and the *she said*. I was after spareness, in both prose and feeling. A sense of the spareness and the fleeting quality of our existence.

It was the most exhilarating book I've ever written, fun, but also very exciting that other writers seemed to be excited by it. I was fascinated by the problems of how to present that tropical world, the hazed sunlight, the strong trade winds, the old ship, the sea, the almost Chaucerian language of those turtlemen, unchanged for centuries.... More than anything I've done, perhaps, *Far Tortuga* was influenced by Zen training. The grit and feel of this present moment, moment after moment, opening out into the oceanic wonder of the sea and sky. When you fix each moment in all its astonishing detail, see its miracle in a fresh light, no similes, no images are needed. They become "literary," superfluous. Aesthetic clutter.

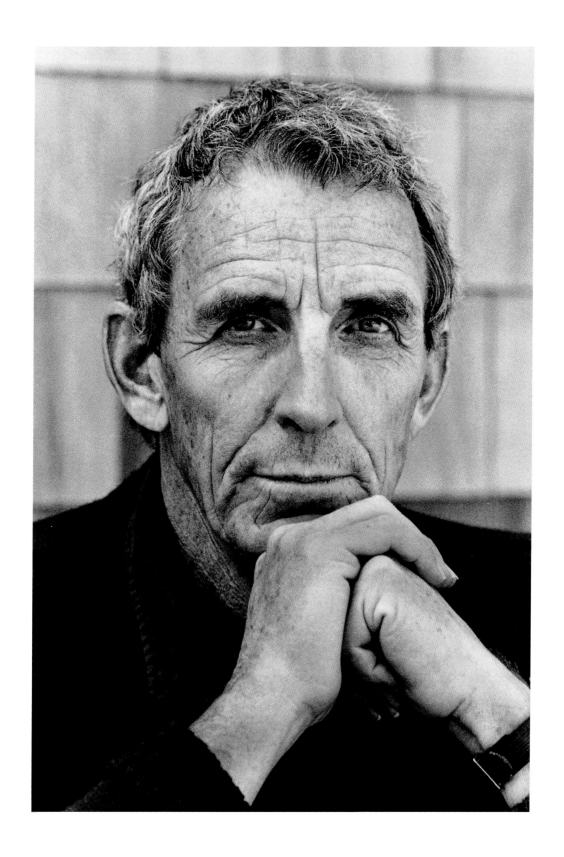

Muriel Spark

Yes, lies do interest me because fiction is lies. Fiction *is* lies. And in order to do this you have got to have a very good sense of what is the truth. You can't do the art of deception, of deceiving people so they suspend disbelief, without having that sense very strongly indeed.... Of course there is a certain truth that emerges from a novel, but you've got to know the difference between fiction and truth before you can write the novel at all. A lot of people don't—a lot of novelists don't—and what you get then is a mess...people run away with the idea that what they are writing is the truth. You must be *all the time* aware it's not.

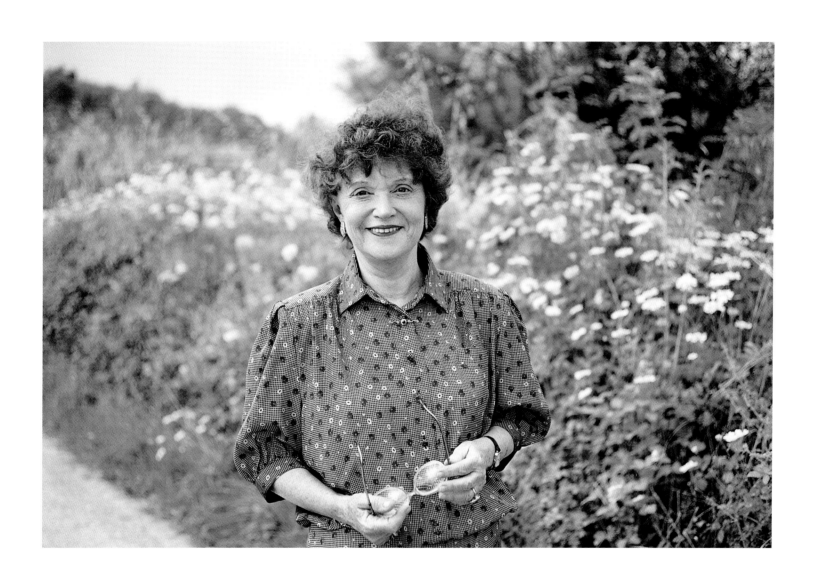

Edward Albee

I discover that I am thinking about a play, which is the first awareness I have that a new play is forming. When I'm aware of the play forming in my head, it's already at a certain degree in development. Somebody will ask, Well, what do you plan to write after the next play? And I'll suddenly surprise myself by finding myself saying, Oh, a play about this, a play about that—I had never even thought about it before. So, obviously, a good deal of thinking has been going on; whether *subconscious* or *unconscious* is the proper term here I don't know. But whichever it is, the majority of the work gets done there. And that period can go on for six months or—in the case of one play—it's a process that went on for three and a half years. Occasionally, I pop the play up to the surface—into the conscious mind to see how it's coming along, to see how it is developing. And if the characters seem to be becoming three-dimensional, all to the good. After a certain point, I make experiments to see how well I *know* the characters. I'll improvise and try them out in a situation that I'm fairly sure *won't* be in the play. And if they behave according to what I consider to be their own natures, then I suppose I have the play far enough along to sit down and write it.

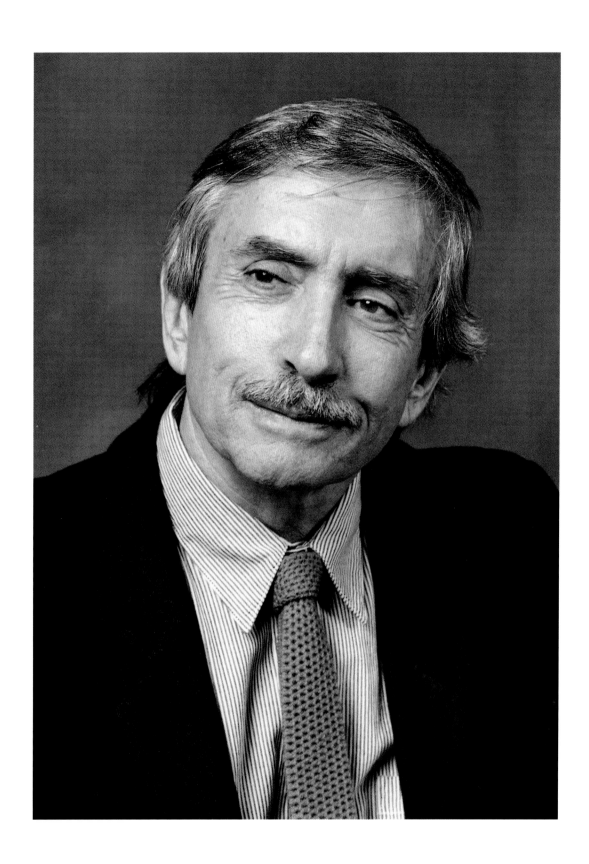

John Irving

The novel is a popular art form, an accessible form. I don't enjoy novels that are boring exercises in show-off writing with no narrative, no characters, no *information*— novels that are just an intellectually discursive text with lots of style. Is their object to make me feel stupid? These are not novels. These are the works of people who want to call themselves writers but haven't a recognizable form to work in. Their subject *is* their technique. And their vision? They have no vision, no private version of the world; there is only a private version of style, of technique. I just completed an introduction to *Great Expectations* in which I pointed out that Dickens was never so vain as to imagine that his love or his use of language was particularly special. He could write very prettily when he wanted to, but he never had so little to say that he thought the object of writing was pretty language. The broadest novelists never cared for that kind of original language. Dickens, Hardy, Tolstoy, Hawthorne, Melville: to such novelists, originality with language is mere fashion; it will pass. The larger, plainer things they are preoccupied with, their obsessions—these will last: the story, the characters, the laughter and the tears.

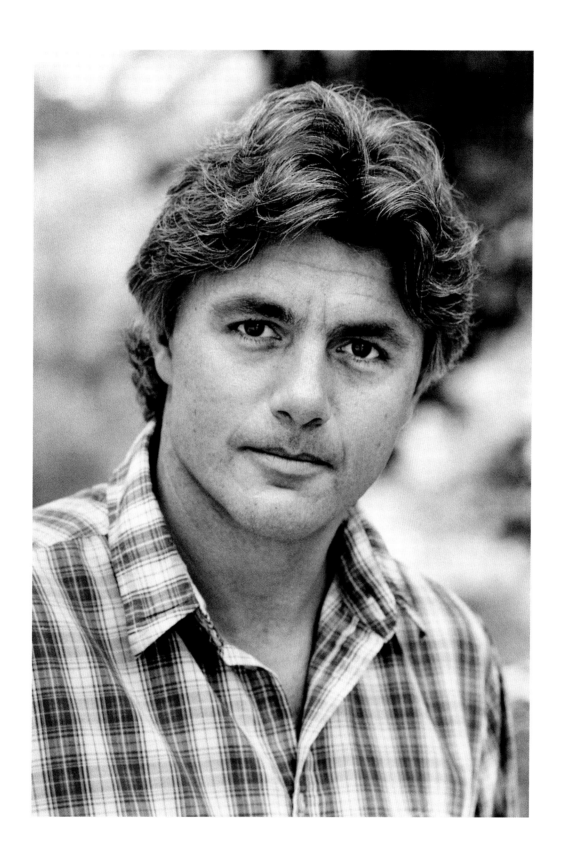

Seamus Heaney

I've worked for my living in institutions for most of my life. I see nothing wrong with it. Of course, there is something perilous about it if you are a poet. You are cushioned from a certain exhilarating exposure to risk when you have a salary and a "situation in life." But it's better to recognize that and get on with the job than to live on the cushion and still go around pretending that you are somehow a free bohemian spirit. Some writers within the academy have this *nous autres, les écrivains* attitude, taking their big stipend and all their freebies and travel grants and Guggenheims but manifesting a kind of *mauvaise foi* by not admitting that their attachment to the academy is their own decision, as it were, and instead just going around mocking this dreary milieu they have opted for. It's an understandable defense mechanism, but it gets on my nerves. It's a sign that they have fallen for the myth of their own creativity. And that they're too anxious about public perception . . . since the myth prescribes the garret rather than the Guggenheim.

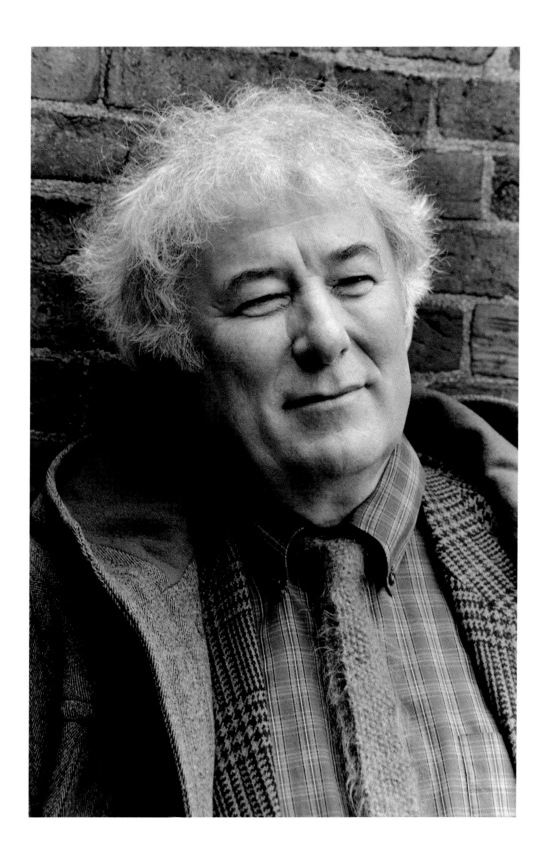

Eudora Welty

Along Mississippi roads you'd now and then see bottle trees; you'd see them alone or in crowds in the front yard of remote farmhouses. I photographed one—a bare crape myrtle tree with every branch ending in the mouth of a colored glass bottle—a blue Milk of Magnesia or an orange or green pop bottle; reflecting the light, flashing its colors in the sun, it stood as the centerpiece in a little thicket of peach trees in bloom. Later, I wrote a story called "Livvie" about youth and old age; the death of an old, proud, possessive man and the coming into flower, after dormant years, of his young wife—a spring story. Numbered among old Solomon's proud possessions is this bottle tree.

I know that the actual bottle tree, from the time of my actual sight of it, was the origin of my story. I know equally well that the bottle tree appearing in the story is a projection from my imagination; it isn't the real one except in that it is corrected by reality. The fictional eye sees in, through, and around what is really there. In "Livvie," old Solomon's bottle tree stands bright with dramatic significance, it stands vulnerable, ready for invading youth to sail a stone into the bottles and shatter them, as Livvie is claimed by love in the bursting light of spring. This I saw could be brought into being in the form of a story.

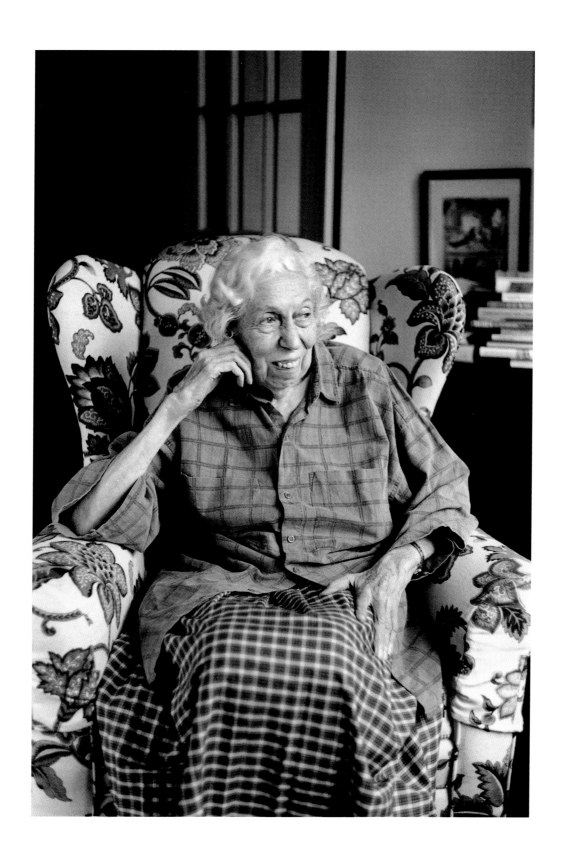

Nadine Gordimer

Looking back at my own youth, the radiant reading days of adolescence, I am puzzled to remember how, deep in D. H. Lawrence, I went through the local library in fervent pursuit of his circle as real-life counterparts of his characters.

Of what possible significance could it have been to me, a sixteen-year-old autodidact living in a small gold-mining town in South Africa, to be told that the mother and Miriam, in *Sons and Lovers,* were Lawrence's own mother and his first love?

What could it matter to me that a rich bohemian eccentric, bizarrely named Ottoline, was rewarded for the house-party hospitality she granted the coal miner's genius son by appearing unflatteringly in one of his later novels?

What could be added to my understanding of, let alone pleasure in, the Lawrence novels and stories by my becoming privy to the gossip of men and women a world away, not only in distance but also in time?

Perhaps the restricted context of my own burgeoning, the small variety of people I knew, made me yearn to connect thrilling fictions as a *realizable possibility* with people who actually were alive once, as I now was, outside the transports of reading which ended with the turning of the last page.

Another explanation to myself is that, beginning to write before I had really lived (the great source of childhood is ready to be tapped, like a rubber tree, only after a certain stage of growth is reached), I was fumbling to find out where fiction came from and how.

What I have learned in my writing life, however, is—in Julian Barnes's words for a writers' manifesto: I MAKE THINGS UP. The writer's imagination creates original beings in the tension between her/his inner development and the pressures of society. Fictional characters are not "about" this real person or that.

Mark Strand

I think what happens at certain points in my poems is that language takes over, and I follow it. It just sounds right. And I trust the implication of what I'm saying, even though I'm not absolutely sure what it *is* that I'm saying. I'm just willing to let it be. Because if I were absolutely sure of whatever it was that I said in my poems, if I were sure, and could verify it and check it out and feel, yes, I've said what I intended, I don't think the poem would be smarter than I am. I think the poem would be, finally, a reducible item. It's this "beyondness," that depth that you reach in a poem, that keeps you returning to it. And you wonder—the poem seemed so natural at the beginning—how did you get where you ended up? What happened? I mean, I like that, I like it in other people's poems when it happens. I like to be mystified. Because it's really that place which is unreachable, or mysterious, at which the poem becomes ours, finally, becomes the possession of the reader. I mean, in the act of figuring it out, of pursuing meaning, the reader is absorbing the poem, even though there's an *absence* in the poem. But he just has to live with that. And eventually, it becomes essential that it exists in the poem, so that something beyond his understanding, or beyond his experience, or something that doesn't quite match up with his experience, becomes more and more his. He comes into possession of a mystery, you know— which is something that we don't allow ourselves in our lives.

Walker Percy

A novelist these days has to be an ex-suicide. A good novel—and, I imagine, a good poem—is possible only after one has given up and let go. Then, once one realizes that all is lost, the jig is up, that after all nothing is dumber than a grown man sitting down and making up a story to entertain somebody or working in a "tradition" or "school" to maintain his reputation as a practitioner of the *nouveau roman* or whatever—once one sees that this is a dumb way to live, that all is vanity sure enough, there are two possibilities: either commit suicide or not commit suicide. If one opts for the former, that is that; it is a *letzte Lösung* and there is nothing more to write or say about it. But if one opts for the latter, one is in a sense dispensed and living on borrowed time. One is not dead! One is alive! One is free! I won't say that one is like God on the first day, with the chaos before him and a free hand. Rather one feels, What the hell, here I am washed up, it is true, but also cast up on the beach, alive and in one piece. I can move my toe up and then down and do anything else I choose. The possibilities open to one are infinite. So why not do something Shakespeare and Dostoyevsky and Faulkner didn't do.

Gayl Jones

I used to say that I learned to write by listening to people talk. I still feel that the best of my writing comes from having *heard* rather than having read. This isn't to say that reading doesn't enrich or that reading isn't important, but I'm talking about foundations. I think my language/word foundations were oral rather than written. But I was also learning how to read and write at the same time I was listening to people talk. In the beginning, *all* of the richness came from people rather than books because in those days you were reading some really unfortunate kinds of books in school. I'm talking about the books children learned to read out of when I was coming up. But my first stories were heard stories—from grown-up people talking. I think it's important that we—my brother and I—were never sent out of the room when grown-up people were talking. So we heard their stories. So I've always heard stories of people generations older than me. I think that's important. I think that's the important thing.

Also, my mother would write stories for us and read them to us. She would read other stories too, but my favorite ones were the ones she wrote herself and read to us. My favorite one of those was a story called "Esapher and the Wizard." So I first knew stories as things that are heard.

I say I'm a fiction writer if I'm asked, but I really think of myself as a storyteller. When I say "fiction," it evokes a lot of different kinds of abstractions, but when I say "storyteller," it always has its human connections. First, the connection to the listener, the hearer; but there's also the connection between the teller and the hearer. "Storytelling" is a dynamic word, a process word. "Fiction" sounds static. "Storytelling" for me suggests possibilities, many possibilities.

Galway Kinnell

Writing is the one trade you can't give up. The history of literature is filled with early blooming poets who've gone on all their lives desperately, doggedly, turning out mediocre verse to maintain their status as poets. Wouldn't it have been better if Wordsworth had, at a certain point, turned to innkeeping or journalism? Rimbaud was the only one able to give it up, and he did that before he was twenty-one. The difficulty is that by comparison other occupations are less interesting. To give up writing would be to close the door on articulating one's deepest experiences. It would be no consolation to think back on work already done. On the contrary, the *Moby Dick* in one's past would be only a brutal reminder of how inattentive, shallow, and faithless one had become. The fear that comes from not writing is the fear of inner deterioration. They say that by tying a dead hen around its neck you can train a dog not to chase hens. There's nothing you can do about an aging poet—even if you tie around him a copy of the late poems of Wordsworth.

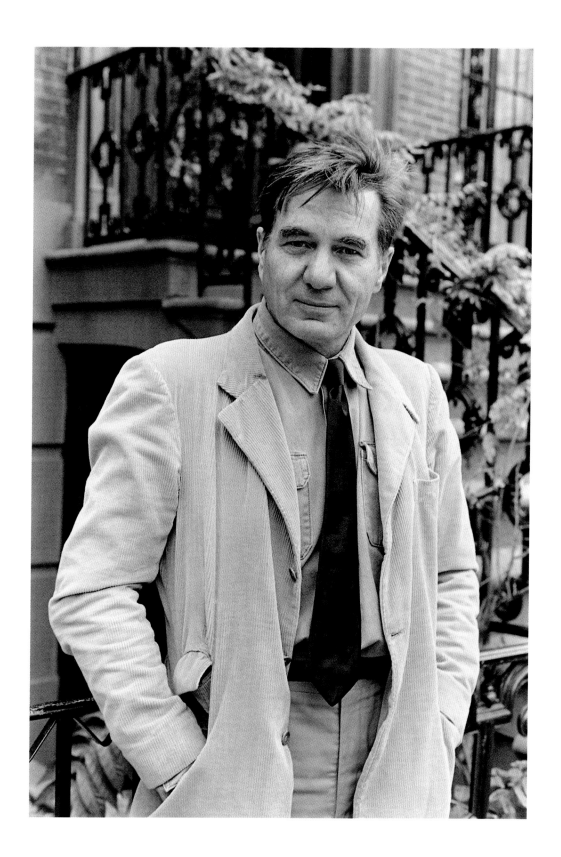

Stanley Kunitz

A trapeze artist on his high wire is performing and defying death at the same time. He's doing more than showing off his skill; he's using his skill to stay alive. Art demands that sense of risk, of danger. But few artists in my period risk their lives. The truth is they're not on a high enough wire. This makes me think of an incident in my childhood. In the woods behind our house in Worcester was an abandoned quarry—you'll find mention of it in "The Testing Tree." This deep-cut quarry had a sheer granite face. I visited it almost every day, alone in the woods, and in my magic Keds I'd try to climb it, till the height made me dizzy. I was always testing myself. There was nobody to watch me. I was testing myself to see how high I could go. There was very little ledge, almost nothing to hold on to. Occasionally I'd find a plant or a few blades of rough grass in the crevices, but the surface was almost vertical, with only the most precarious toehold. One day I was out there and I climbed—oh, it was a triumph—almost to the top. And then I couldn't get down. I couldn't go up or down. I just clung there that whole afternoon and through the long night. Next morning the police and fire department found me. They put up a ladder and brought me down. I must say my mother didn't appreciate that I was inventing a metaphor for poetry.

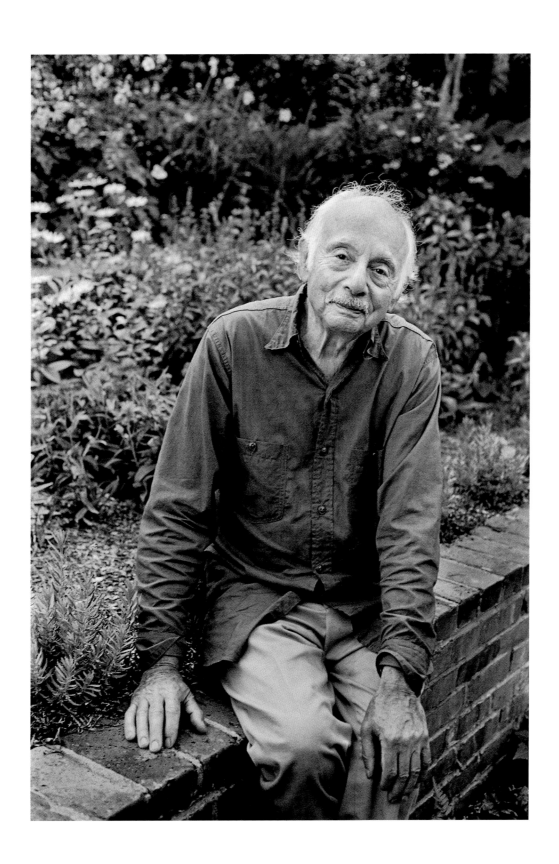

Philip Roth

Beginning a book is unpleasant. I'm entirely uncertain about the character and the predicament, and a character in his predicament is what I have to begin with. Worse than not knowing your subject is not knowing how to treat it, because that's finally everything. I type out beginnings and they're awful, more of an unconscious parody of my previous book than the breakaway from it that I want. I need something driving down the center of a book, a magnet to draw everything to it—that's what I look for during the first months of writing something new. I often have to write a hundred pages or more before there's a paragraph that's alive. Okay, I say to myself, that's your beginning, start there; that's the first paragraph of the book. I'll go over the first six months of work and underline in red a paragraph, a sentence, sometimes no more than a phrase, that has some life in it, and then I'll type all these out on one page. Usually it doesn't come to more than one page, but if I'm lucky, that's the start of page one. I look for the liveliness to set the tone. After the awful beginning come the months of freewheeling play, and after the play come the crises, turning against your material and hating the book.

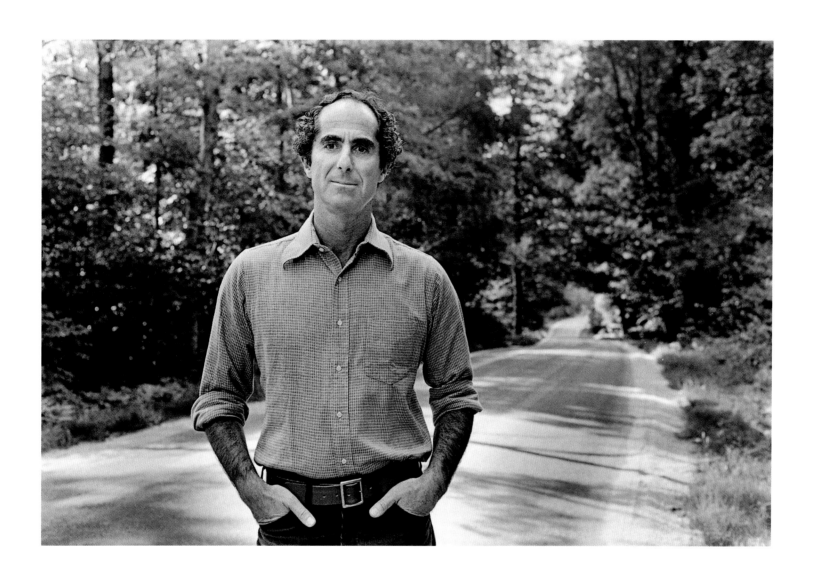

E. L. Doctorow

The blank mind, when it has no wish to think or improve upon existence, grants you a simple unreflective being that is very pleasant and peaceable. Fortunately it doesn't last. One day I was sitting in my study, on the top floor of my house in New Rochelle, and I found myself staring at the wall. Perhaps I felt it was representative of my mind. I decided to write about the wall. And then about all the walls together. "My house was built in 1906," I wrote. "It is a great, ugly three-story manse, with dormers, bay windows, and a screened porch. When it was new the shingles were brown and striped awnings shaded the windows. . . ." I then imagined what New Rochelle looked like when the house was new. In those days trolley cars ran along the avenue at the bottom of the hill. People wore white in the summer. Women carried parasols. I thought of Teddy Roosevelt, who was president at the time. And the blank page of my mind began to fill with the words of a book.

But wherever books begin, in whatever private excitement of the mind, whether from the music of words, or an impelling anger, or the promise of an unwritten-upon page, the work itself is hard and slow, and the writer's illumination becomes a taskmaster, a ruling discipline, jealously guarding the mind from all other, and necessarily errant, private excitements until the book is done. You live enslaved in the book's language, its diction, its universe of imagery, and there is no way out except through the last sentence.

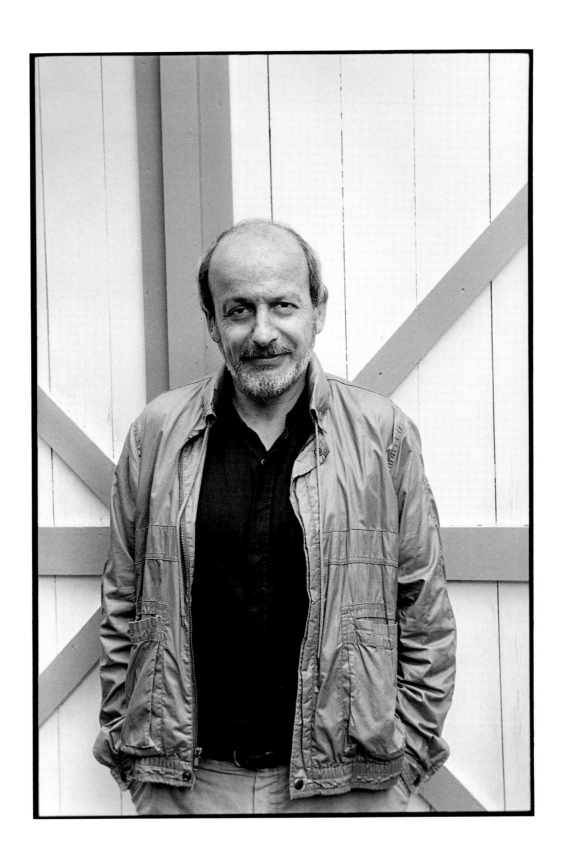

Doris Lessing

This question of I, who am I, what different levels there are inside of us, is very relevant to writing, to the process of creative writing about which we know nothing whatsoever. Every writer *feels* when he, she, hits a different level. A certain kind of warning or emotion comes from it. But you don't know who it is who lives there. It is very frightening to write a story like "To Room 19," for instance, a story soaked in emotions that you don't recognize as your own.

When I wrote *The Golden Notebook* I deliberately evoked the different levels to write different parts of it. To write the part where two characters are a bit mad, I couldn't do it, I couldn't get to that level. Then I didn't eat for some time by accident (I forgot) and found that there I was, I'd got there. And other parts of *The Golden Notebook* needed to be written by "I's" from other levels. That is a literary question, a problem to interest writers.

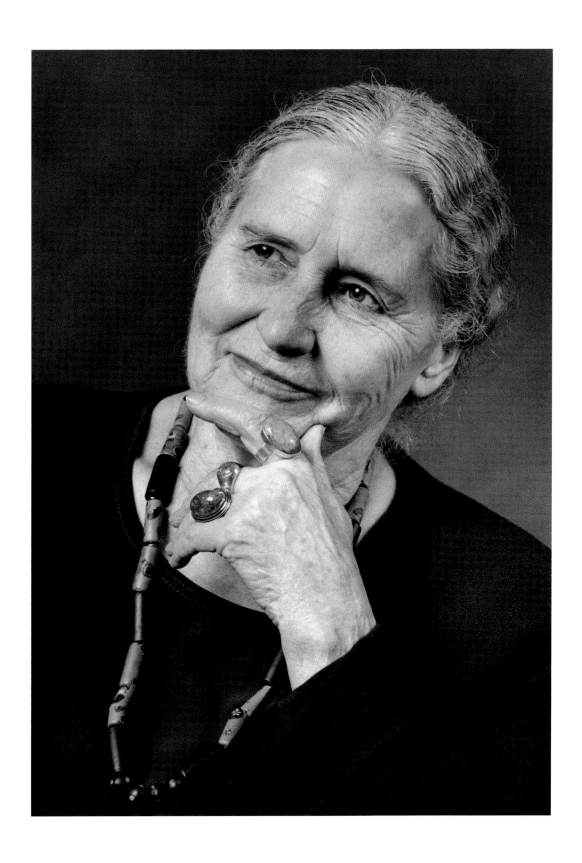

Harold Rosenberg

Novelties in painting and sculpture receive notice in the press as new *facts* long before they have qualified as new *art*. The public presence of images that demand elucidation exerts pressure upon art institutions and educators to exhibit and comment upon them. If the work continues to hold the spotlight, this comment takes place within a heavy drift toward approval. Dealers, curators, collectors become committed to the new art; critics eager to keep up with, and even ahead of, the flux of innovation discover features that link it to admired precedents. To deny the significance of the new product begins to seem futile, since whatever is much seen and talked about is already on its way to becoming a fait accompli of taste. By the mere quantity of interest aroused by its novelty, the painting is nudged into art history. Once there, its goodness or badness may still be debated, but unless the whole culture is under attack its status as art is secure. Having a place in art history is *the* value; through attaining this place, the work's own qualities become part of the standards by which the work is judged.

Basic critical issues that relate to new art must therefore be decided in the interlude between its first appearance as an innovation and its firm engrafting upon the historical trunk. There exists, one might say, a critical interval. To prolong the period of reflection and judgment-making is nothing less than to keep alive freedom of choice against the inertia of sheer fact. In our society the responsibility for holding open aesthetic choice rests primarily on institutions of contemporary art: museums, university art departments, professional publications. It is up to them, in the interest of artistic creation, to dam the flow of journalistic human interest in art. How well they have been fulfilling this responsibility is indicated by the fact that the critical interval has been shrinking at a rapidly increasing rate; reputations are now being made in art as fast as on Broadway and in Hollywood.

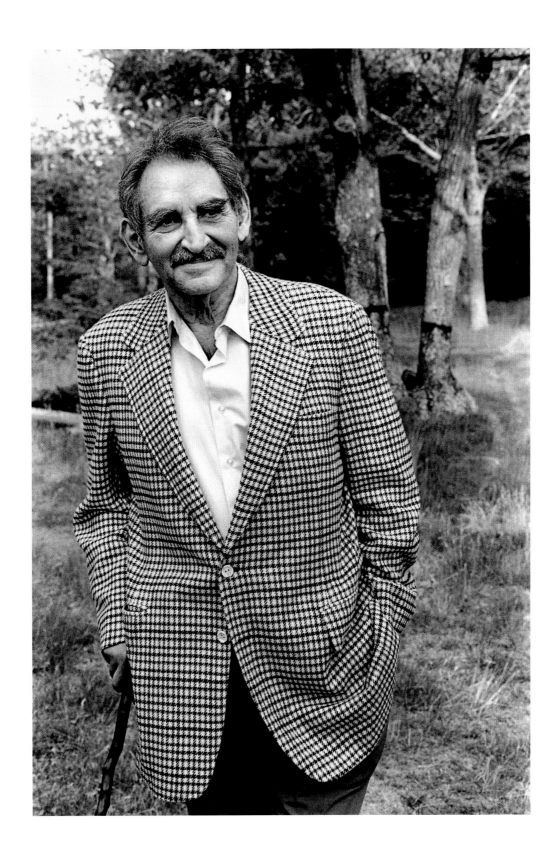

Margaret Drabble

It's extremely difficult to be a local writer these days. British writers are often told that it's better to be American. British writers like Martin Amis and Salman Rushdie spend much of their time in America, partly because they believe that that is where the big themes are, and because that is where the power is. There is a truth in that—in some ways an unfortunate truth—but it doesn't tempt me as a writer, because I feel my life and my material are here, in England. If you know your own place intensely, your perceptions can become global. On the other hand, the larger global world is very interesting physically, and nowadays very accessible, so I am torn between wanting to see as much as I can, and knowing that I can't deal with what I see. It's a paradox. It might have been easier, as a writer, to be Emily Brontë, who didn't have much choice, and never wanted to leave her own village.

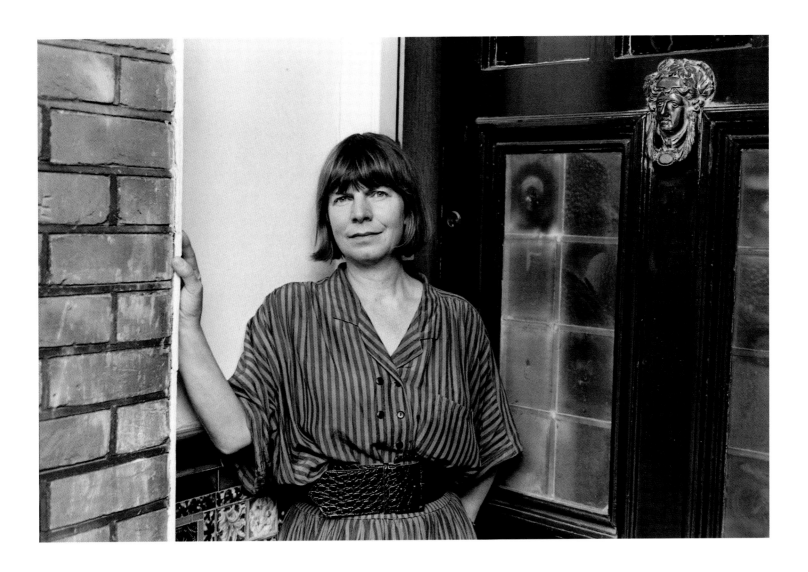

Harold Brodkey

There's a very complicated idea that lies behind the notion of the public space in which the narrator addresses the reader. It's an idea that has to do with language being actual, being temporal and spatial, to be Kantian about it. In a piece of writing the language runs along on the page and in the mind of a reader; in that language is no actual physical space, but it should carry the implication of a physical-social location. If you've been to a large Edwardian house you may have seen a small room with a fireplace and a couch, and perhaps two chairs—not a formal, large room where you can carry on, but one where you can sit and talk. It's where you gossip. Henry James has a tone of address as if he's arrived at such a large house, not his own, and he is seated by the fire; an invisible interlocutor or audience listens closely. Walt Whitman speaks outdoors it seems to me. The space Whitman suggests is complex and American and I think beautiful and a completely new invention. One thing that is unique about it is that there's no tinge of social class in it whatsoever. Jane Austen's writing suggests a drawing room sort of space; Hemingway's, on a bar stool or in a club car; it changes: he's complicated. Emily Dickinson creates a marvelous public space too, and one of the marvelous things about it is that it is so clearly an invention since it isn't based on being public; it is without a sense of the public.

I think this is a major part of what's called *voice*. You imagine the space, and then create the voice to fill it.

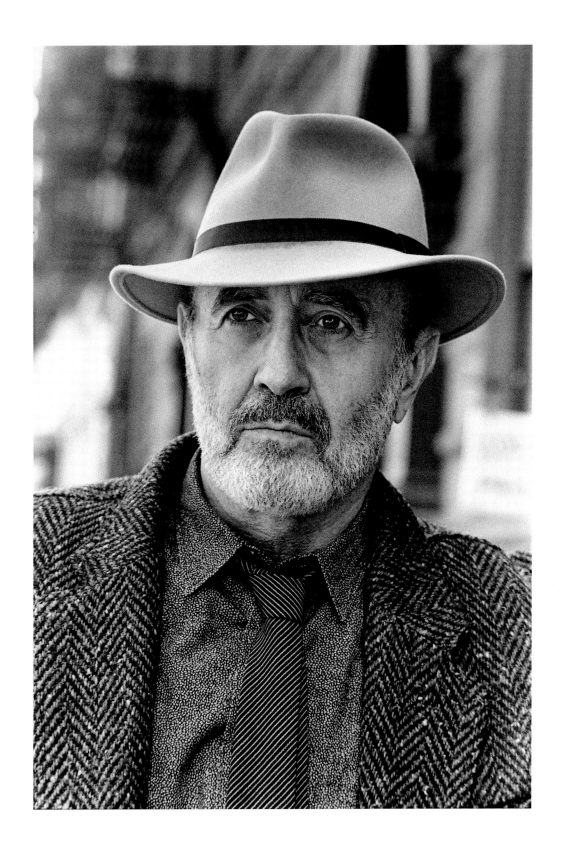

Margaret Atwood

My theory is that writing poetry and writing prose involve two different areas of the brain, with some overlap. When I am writing fiction, I believe I am much better organized, more methodical; one has to be when writing a novel. Writing poetry is a state of free float.

The genesis of a poem for me is usually a cluster of words. The only good metaphor I can think of is a scientific one: dipping a thread into a supersaturated solution to induce crystal formation. I don't think I solve problems in my poetry; I think I uncover problems. Then the novel seems a process of working them out. I don't think of it that way at the time; that is, when I'm writing poetry, I don't know I'm going to be led down the path to the next novel. Only after I've finished the novel can I say, well, this poem was the key. The poem opened the door.

When I'm writing a novel, what comes first is an image, scene, or voice. Something fairly small. Sometimes that poem I've already written. The structure or design gets worked out in the course of the writing. I couldn't write the other way round, with structure first. It would be too much like paint-by-numbers. . . . It's almost as if the poems open something, like opening a room or a box, or a pathway. And then the novel can go in and see what else is in there. I'm not sure this is unique. I expect that many other ambidextrous writers have the same experience.

Chinua Achebe

I loved stories, stories told in our home, first by my mother, then by my elder sister.

When I began going to school and learned to read, I encountered stories of other people and other lands. In one of my essays, I remember the kind of things that fascinated me. Weird things, even, about a wizard who lived in Africa and went to China to find a lamp... fascinating to me because they were about things remote, and almost ethereal.

Then I grew older and began to read about adventures in which I didn't know that I was supposed to be on the side of those savages who were encountered by the good white man. I instinctively took sides with the white people. They were fine! They were excellent. They were intelligent. The others were not... they were stupid and ugly. That was the way I was introduced to the danger of not having your own stories. There is that great proverb, that until the lions have their own historian, the story of the hunt will always glorify the hunter. That did not come to me until much later. Once I realized that, I had to be a writer. I had to be that historian. It's not one man's job. It's not one person's job. But it is something we have to do, so that the story of the hunt will also reflect the agony, the travail, the bravery, even, of the lions.

Peter Carey

I am Australian. Our founding fathers and mothers did not come to our shores in search of liberty, they came to prison. Very few modern Australians are descended from those first convicts, but I believe that they affected the character of our nation forever—after all, not many modern Americans have ancestors who were on the *Mayflower,* but those folks on the *Mayflower* affected America forever.

Unlike Americans, Australians do not like to celebrate this moment when the nation is born, and it has been something of a passion for me to do just that. We carry a great deal of furniture about our beginnings. It's a complicated business to discuss in so brief a form as this, but there is a great deal of self-hatred, denial, grief, and anger, all unresolved. It took a long time before I could think of exactly how I might use these passions to fuel a novel. Then one day, contemplating the figure of Magwitch, the convict in Charles Dickens's *Great Expectations,* I suddenly thought, THIS MAN IS MY ANCESTOR. And then: This is UNFAIR!

Dickens's Magwitch is foul and dark, frightening, murderous. Dickens encourages us to think of him as the "other," but this was my ancestor, he was not "other." I wanted to reinvent him, to possess him, to act as his advocate. I did not want to diminish his "darkness" or his danger, but I wanted to give him all the love and tender sympathy that Dickens's first-person narrative provides his English hero Pip. That's where I started. The journey itself is, of course, far more complicated.

Edna O'Brien

When I say I have written from the beginning, I mean that all real writers write from the beginning, that the vocation, the obsession, is already there, and that the obsession derives from an intensity of feeling which normal life cannot accommodate. I started writing snippets when I was eight or nine, but I wrote my first novel when I left Ireland and came to live in London. I had never been outside Ireland and it was November when I arrived in England. I found everything so different, so *alien....* So in a sense *The Country Girls,* which I wrote in those first few weeks after my arrival, was my experience of Ireland and my farewell to it. But something happened to my style which I will tell you about. I had been trying to write short bits, and these were always flowery and over-lyrical. Shortly after I arrived in London I saw an advertisement for a lecture given by Arthur Mizener on Hemingway and Fitzgerald. You must remember that I had no literary education, but a fervid religious one. So I went to the lecture and it was like a thunderbolt—Saul of Tarsus on his horse! Mizener read out the first paragraph of *Farewell to Arms* and I couldn't believe it—this totally uncluttered, precise, true prose, which was *also* very moving and lyrical. I can say that the two things came together then: my being ready for the revelation and my urgency to write. The novel *wrote itself,* so to speak, in a few weeks. All the time I was writing it I couldn't stop crying, although it is a fairly buoyant, funny book. But it was the separation from Ireland which brought me to the point where I *had* to write, though I had always been in love with literature.

John Barth

The great guides were the books I discovered in the Johns Hopkins library, where my student job was to file books away. One was more or less encouraged to take a cart of books and go back into the stacks and not come out for seven or eight hours. So I read what I was filing. My great teachers (the best thing that can happen to a writer) were Scheherazade, Homer, Virgil, and Boccaccio; also the great Sanskrit tale-tellers. I was impressed forever with the width as well as the depth of literature—just what a kid from the sticks, from the swamp, in my case, needed.

My apprenticeship was a kind of Baptist total immersion in "the ocean of rivers of stories"—that's the name of one of those old Sanskrit jobs that I read in my filing days...one volume at a time up to volume seventeen. I think the sweetest kind of apprenticeship that a narrative artist can serve is that sort of immersion in the waters of narrative, where by a kind of osmosis you pick up early what a talented writer usually learns last: the management of narrative pace, keeping the story going.

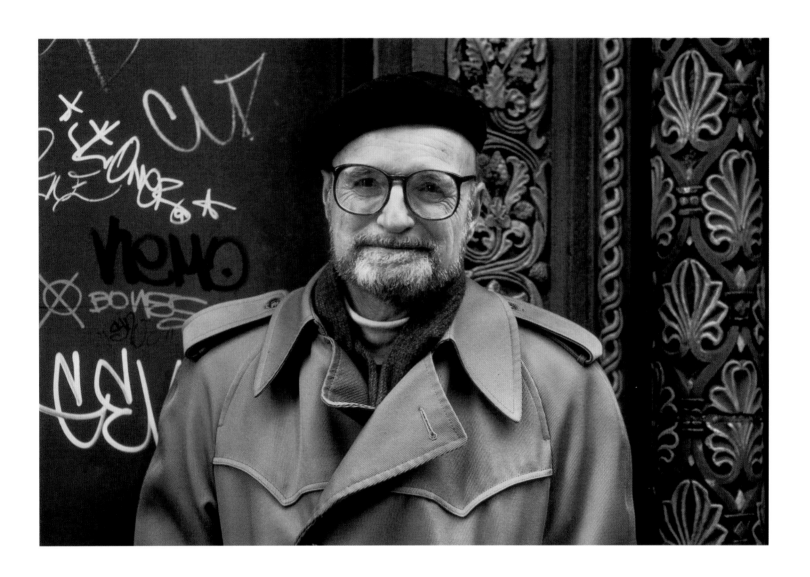

Richard Ford

Sometimes I just get interested in a word. In 1991 or so I found myself writing in my notebook and using the word *independence* a lot. It kept coming up in one context or another. And there's this great line of Henry Moore's that Donald Hall quotes, "Never think of a surface but as the extension of a volume." So, when I see a word I'm interested in, what that means to me is that the word's the surface of an extended volume. It's as if the word has density. And if I can dedicate some language to it, use it, put it in context, maybe I can invent something new with that unseen volume. So, based on this experience, I decided to write a novel in which I would use the word *independence,* maybe make independence the primary concern. It seemed natural, then, to set the book at the Fourth of July. I was also attracted to Springsteen's wonderful song, "Independence Day," in which a son sings a kind of lament upon leaving to his father, with the memorable line, "Just say good-bye, it's Independence Day." I hadn't realized how much independence, in the most conventional sense, suggests leave-taking, putting distance between yourself and something else—other people, getting out of their orbit. So, then, I wondered something else: if independence might mean a freedom to make contact with others, rather than just freedom by severance. It's part of my general scheme to try to write things that are affirming, although I don't always succeed. It's easier to write about things that fuck up, things that go kaflooey, people leaving and doors slamming. That's dramatic. I'm more interested, though, in what happens *after* somebody walks out the door. I'm interested in what they do later. Fiction, for me, is about consequence. The most constructive impulse in my life is that I don't usually walk out the door. I don't do exits.

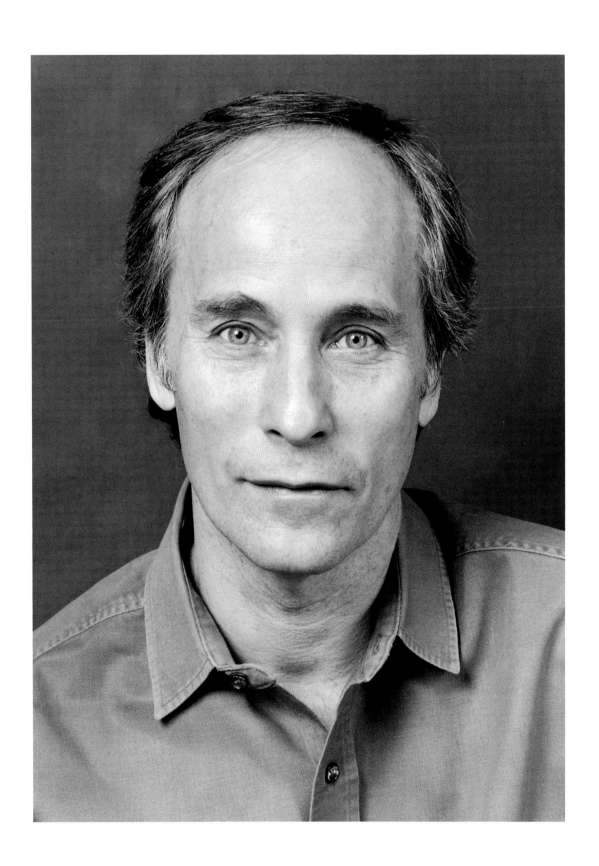

Laurie Colwin

I feel that writers have to be marginal. This is an unappealing opinion these days, when writers do nothing, it seems to me, but try to fit into the available society. I feel that a writer is supposed to be outside that. The purpose of a writer is to give a countervailing view to the prevailing opinion. I think that's the position that most writers take before they even sit down at the typewriter. Because they're not like other people. They're not *supposed* to be like other people. They're supposed to be different from other people, and then they're supposed to write it down. They're supposed to see what's *there*. Mary McCarthy said—this is one of my mottoes (I have about three mottoes)—"I believe in truth, and I believe that it is knowable." And Red Holzman, the former coach of the New York Knicks, said, "Never take medical advice from a waiter." I think those are two mottoes that will get you straight through life.

I think you can think about a thing until it yields its own sense to you. That, it seems to me, is the writer's job. Many people we know—mothers, for instance—not us mothers but *our* mothers—find a lot of consolation in seeing what makes them feel better. We all have friends who we're always trying to shake into consciousness, but what they really want to do is believe what makes them feel better to believe, even if it isn't accurate. I think what writers have to do is see what's there, or as close as they can come to what is there, and describe it....

You put your feet up, and you look out the window, and then you interview yourself about the particular issue. You turn it around in your mind, and you think about what everybody else said, and you reflect on what they said and what you might say back to them.... It takes a lot of mental fortitude.

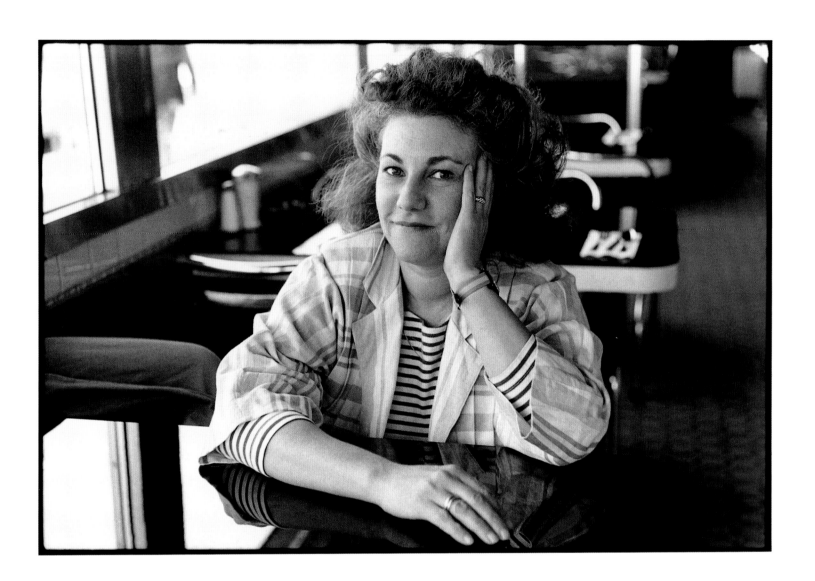

Tony Kushner

The kind of theater that I do, which is very much in the tradition of psychological narrative realism, may not actually be about moving people to action, or at least it would be an odd ambition for an artist in that tradition to have. I really believe that this kind of theater works in the way that dreams work, that the deal you make with the audience is you can sit in the dark and nobody's gonna come up and put their hand on you, and nobody's gonna come up and scream in your face that you're not doing enough to save the whales, or something. You're going to be left alone, and you can be in this kind of semitrance state with a bunch of other people who will be sharing a vision that you're watching. That's the deal. What we get to do, since you've agreed to come and pay your money and sit in the dark, is enact scenes of pity and terror that you really wouldn't want to be in the middle of in daily life. Because you're safe, you're willing to watch them. You'll control your anxieties. We're presenting them to you in metaphors, in aesthetic forms, in vessels that make them watchable. And then it's up to you to decide whether you forget the dream when you wake up or when the lights come up, or whether you remember it.

I believe that everybody in a room together having the same experience creates something. It creates an energy. It creates a community. It creates a phenomenon that didn't exist before, and that in almost a mystical way creates good in the world, and it also empowers people and makes it more likely that they will act.

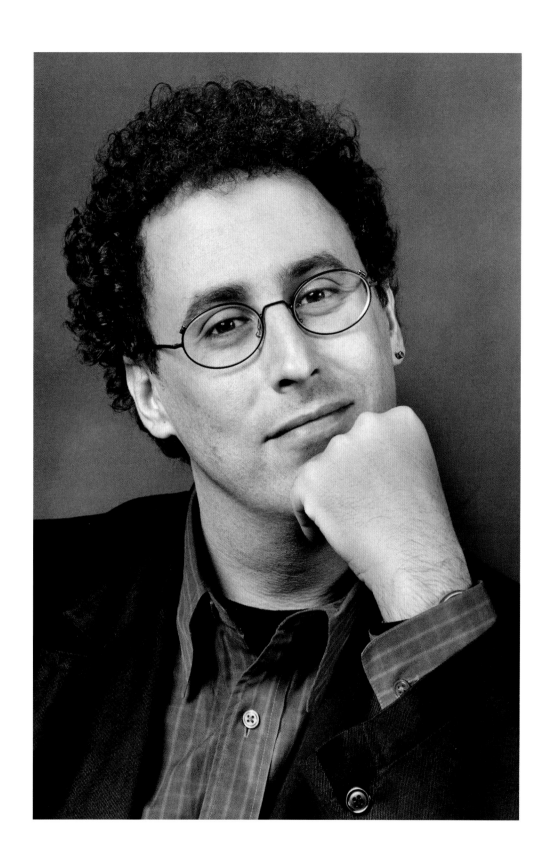

Iris Murdoch

Great art is connected with courage and truthfulness. There is a conception of truth, a lack of illusion, an ability to overcome selfish obsessions, which goes with good art, and the artist has got to have that particular sort of moral stamina. Good art, whatever its style, has qualities of hardness, firmness, realism, clarity, detachment, justice, truth. It is the work of a free, unfettered, uncorrupted imagination. Whereas bad art is the soft, messy, self-indulgent work of an enslaved fantasy. Pornography is at one end of that scale, great art at the other end. . . .

I'd want to make a distinction between fantasy and imagination, not the same as Coleridge's, but a distinction between the expression of immediate selfish feelings and the elimination of yourself in a work of art. The most obvious case of the former would be the novel where the writer is the hero and is always succeeding. He doesn't succeed at first, but he's very brave, and all the girls like him, and so on. That tends to spoil the work. . . . What is important is an ability to have an image of perfection and to expel fantasy and the sort of lesser, egoistic cravings and the kind of imagery and immediate expressions that might go with them, and to be prepared to think and to wait.

John Edgar Wideman

The Iliad and *The Odyssey* are products of oral literature and everybody wants to jump in line to claim the Greeks as the father of their literature, at least all European cultures do. For me the models of eloquence that were most important—I'm very clear about this now—were the women in my family. I was lucky enough to grow up in a household of women. Not only did they pamper me, take care of me, and make me feel that I was the center of the world, but they talked all the time to one another. In that context I learned to listen, because they were addressing things to me. The speech was coded so that I wouldn't understand everything, because they were talking about their boyfriends, about my uncles, about my father. They didn't want me to understand too much, but they weren't going to shut up either. So already what I was observing and hearing was a very flexible and fluid kind of vernacular that could assume a register that would exclude "Mr. Big Ears" (me) who wasn't supposed to understand everything. The people who were using that vernacular could make that kind of flexible switch. It's fair enough to say that I lived in an oral culture, growing up in Homewood around talkers—the barbershop, women at home, the preacher on Sunday, the preacher on the radio, the music. When I became a little older, as a teenager, there were the talkfest competitions like "the dozens" and "signifying," those male rituals of talk that made our group what it was, gave people personalities and status. If you lived in that kind of culture, you realized first off, very quickly, that there are good talkers and bad talkers, and a mile in between, and some were very good talkers indeed. The joy that the very best talkers bring is a kind of ecstasy.

Annie Proulx

Imagination is the human mind's central life strategy. It is how we anticipate danger, pleasure, threat. The imagination is how our expectations are raised and formulated; it excites and ennobles our purpose in life. The imagination blocks out hunger, bodily harm, bad luck, injury, loneliness, insult, the condition of the marooned person or the orphan, grief and disappointment, restlessness, desperation, imprisonment, and approaching death. And from the imagination spring the ideas, the actions, and the beliefs that we hold.

For many people—for me certainly—the life of the mind, the realm of the imagination, is a more brilliant and compelling one than the world we live in. It is everything. Imagination is the central pivot of human life.

People who are poor or who are in "socially disadvantaged" situations are forced by circumstance to use their imagination more vigorously than people in more comfortable positions. I can't remember who said it, but I agree that "our poets are the children of the poor." If you have nothing and no place in the world, the imagination is an engine of incredible power, both to lift you out of where you are and to impel you into another reality.

Oliver Sacks

The people in this book [*An Anthropologist on Mars*] have been visited by neurological conditions as diverse as Tourette's syndrome, autism, amnesia, and total colorblindness. They exemplify these conditions, they are "cases" in the traditional medical sense—but equally they are unique individuals, each of whom inhabits (and in a sense has created) a world of his own.

The exploration of deeply altered selves and worlds is not one that can be fully made in a consulting room or office. The French neurologist François Lhermitte is especially sensitive to this, and instead of just observing his patients in the clinic, he makes a point of visiting them at home, taking them to restaurants or theaters, or for rides in his car, sharing their lives as much as possible. (It is similar, or was similar, with physicians in general practice. Thus when my father was reluctantly considering retirement at ninety, we said, "At least drop the house calls." But he answered, "No, I'll keep the house calls—I'll drop everything else instead.")

With this in mind, I have taken off my white coat, deserted, by and large, the hospitals where I have spent the last twenty-five years, to explore my subjects' lives as they live in the real world, feeling in part like an anthropologist, a neuroanthropologist, in the field—but most of all like a physician, called here and there to make house calls, house calls at the far borders of human experience.

Alice Munro

There's a kind of excitement and faith that I can't work without. There was a time when I never lost that, when it was just inexhaustible. Now I have a little shift sometimes when I feel what it would be like to lose it, and I can't even describe what *it* is. I think it's being totally alive to what this story is. It doesn't even have an awful lot to do with whether the story will work or not.

It's not the giving up of the writing that I fear. It's the giving up of this excitement or whatever it is that you feel that makes you want to write.

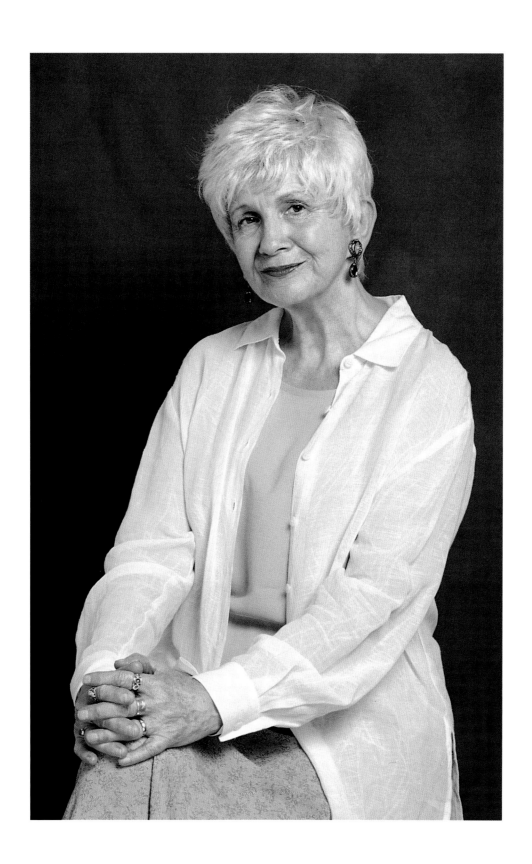

Edwidge Danticat

I have always split my memories into two realms: one of real memory and one of fictional memory. Real memory is fragmented, messy, disorganized, has no clever dialogue and you don't always get the ending of your choice. That's why I prefer to write fiction, though it is fiction that draws heavily from certain moments in my life. With my fictional memories, I can use lies to tell a greater truth, winding a different kind of tale out of myself, one in which the possibilities for tangents and digressions are boundless; I can also weave a more elaborate web, where everyone's life can serve as a thread, including my own.

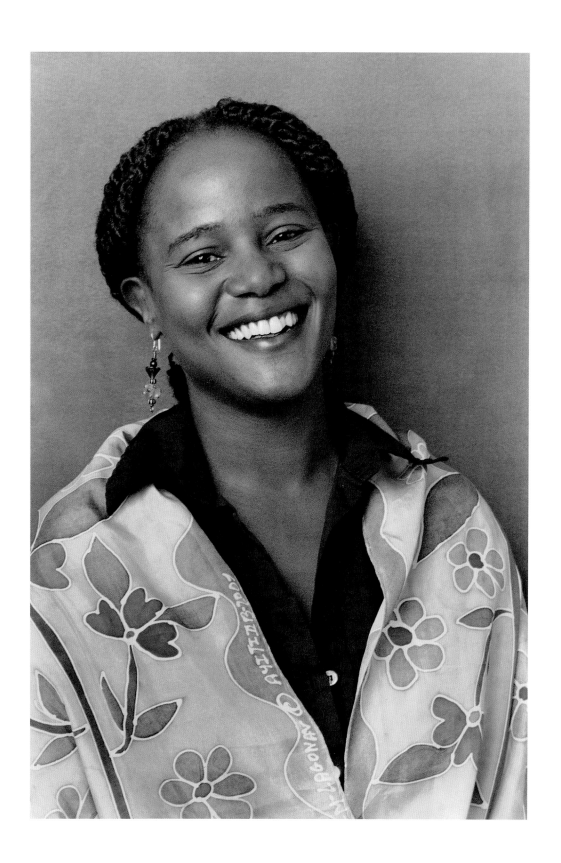

V. S. Naipaul

After I left Oxford, really in great conditions of hardship, I began to write something intensely serious. I was trying to find my own voice, my tone—what was really me and not borrowed or acting. This serious voice led me into great shallows of depression, which dragged on for a while until I was told to abandon it by someone to whom I had sent the manuscript. He told me it was rubbish; I wanted to kill him but deep down in my heart I knew he was absolutely right. I spent many weeks feeling wretched because it had been five years and nothing was happening. There was this great need to write, you see. I had decided it was to be my livelihood—I had committed my life to it. Then something happened: out of that gloom, I hit upon my own voice. I found the material that was my own voice; it was inspired by two literary sources: the stories of my father and a Spanish picaresque novel, the very first published, in 1554, *Lazarillo Tormes*. It is a short book about a little poor boy growing up in imperial Spain, and I loved its tone of voice. I married these two things together and found that it fitted my personality: what became genuine and original and mine really was fed by these two, quite distinct sources.

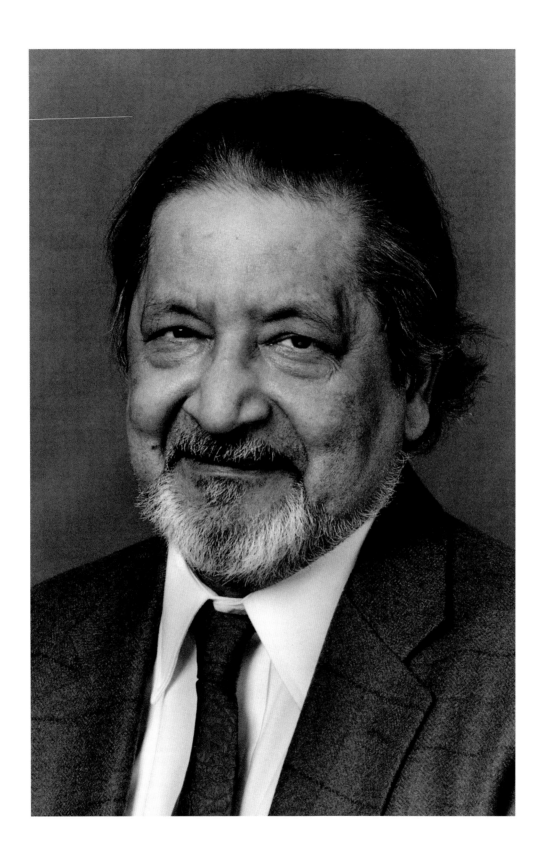

Gabriel García Márquez

My mother asked me to accompany her to Aracataca, where I was born, and to sell the house where I spent my first years. When I got there it was at first quite shocking because I was now twenty-two and hadn't been there since the age of eight. Nothing had really changed, but I felt that I wasn't really looking at the village, but I was *experiencing* it as if I were reading it. It was as if everything I saw had already been written, and all I had to do was to sit down and copy what was already there and what I was just reading. For all practical purposes everything had evolved into literature: the houses, the people, and the memories. I'm not sure whether I had already read Faulkner or not, but I know now that only a technique like Faulkner's could have enabled me to write down what I was seeing. The atmosphere, the decadence, the heat in the village were roughly the same as what I had felt in Faulkner. It was a banana plantation region inhabited by a lot of Americans from the fruit companies which gave it the same sort of atmosphere I had found in the writers of the Deep South. Critics have spoken of the literary influence of Faulkner but I see it as a coincidence: I had simply found material that had to be dealt with in the same way that Faulkner had treated similar material.

From that trip to the village I came back to write *Leaf Storm,* my first novel. What really happened to me in that trip to Aracataca was that I realized that everything that had occurred in my childhood had a literary value that I was only now appreciating. From the moment I wrote *Leaf Storm* I realized I wanted to be a writer and that nobody could stop me and that the only thing left for me to do was to try to be the best writer in the world.

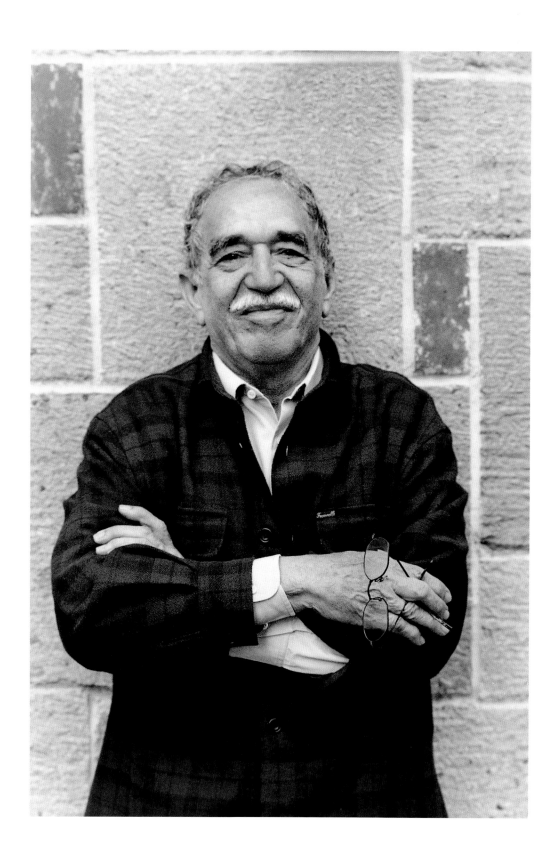

Joyce Carol Oates

One must be pitiless about this matter of "mood." In a sense the writing will *create* the mood. If art is, as I believe it to be, a genuinely transcendental function—a means by which we rise out of limited, parochial states of mind—then it should not matter very much what states of mind or emotion we are in. Generally I've found this to be true: I have forced myself to begin writing when I've been utterly exhausted, when I've felt my soul as thin as a playing card, when nothing has seemed worth enduring for another five minutes...and somehow the activity of writing changes everything. Or appears to do so. Joyce said of the underlying structure of *Ulysses*—the Odyssean parallel and parody—that he really didn't care whether it was plausible, so long as it served as a bridge to get his "soldiers" across. Once they were across, what does it matter if the bridge collapses? One might say the same thing about the use of one's self as a means for the writing to get written. Once the soldiers are across the stream...

Billy Collins

It took a long time for poetry to be able to include the everyday, and now it devotes a lot of energy to celebrating it. In mentioning the simple array of things around us, I am trying to evoke a kind of haiku-like presentation of the world in an unadorned condition, without the enhancing lift of metaphor. I think one of the devices that seems to reoccur in my poems is ironic deflation. I use the pedestrian detail—the dog asleep on the floor, the bird out the window—to reverberate against the loftiness of literary tradition. I mean Milton is dead, but the dog is breathing there by my chair. Haiku is saying that the present moment is everything. Nothing exists outside it except two abysses on either side. If one particular moment happens to be filled by a cherry tree in blossom and a sliver of a moon, then to merely mention those things (in a seventeen-syllable enclosure) is to celebrate the fact that you exist, that you are the only creature in the universe who occupies these exact time/space coordinates.

We live in lowercase times, which is to say allegory is dead. You can no longer open a poem with the figure of Charity, not to mention Chastity, the deadest of the virtues. Underlying this procedure in poetry is the assumption that the things around us—the tree, but also the broom and the ice cube—might hold clues to the world beyond—might provide access to the spiritual or at least the abstract dimensions. Emerson called it the "speaking language of things," the capacity of the material world to lead us beyond.

Nathan Englander

I don't believe in treating literature like snake oil. It doesn't have to promise any curative effects or to help us lose weight or reawaken dormant hair follicles. I think, very simply, that literature's purpose is to be read.

In the writing of stories, even that claim falls apart for me. I do my very best to concentrate only on telling the best story that I can. It's really not about anything else, not to educate, or enlighten or entertain. It's just about the story that I'm working on, what that story needs and how to make it work.

I could go on forever telling stories about stories that have changed people's lives, about where books fit into the food chain of knowledge and inspiration, and how a book's subversive form—its physical dimensions—allows whole worlds to be smuggled beyond borders. I could share my own teary-eyed testimony about the ways in which a certain Dinesen story affected me over my morning coffee.... But I really, truly think all that muddles. It can't be the goal for the writer and it can't be the weight set on top of the not-yet-read book.

So why stories? Because it's a joy for me to write stories, and once I get started I even forget that. Then it is about the work, about the story itself. And the same happens with the reading. Sometimes I open a book with the intention to get smarter or to be entertained or even to get myself to sleep. But once I'm reading, if everything is in place, once again, it's only about the story and nothing more.

Sam Shepard

When I have a piece of writing that I think might be ready, I test it with actors, and then I see if it's what I imagined it to be. The best actors show you the flaws in the writing. They come to a certain place and there's nothing there, or they read a line and say, "Okay, now what?" That kind of questioning is more valuable than anything. With the very best actors I can see it in the way they're proceeding. Sometimes I instinctively know that this little part at the end of scene two, act one is not quite there, but I say to myself, "Maybe we'll get away with it." A good actor won't let me. Not that he says, "Hey, I can't do this"; I just see that he's stumbling. And then I have to face up to the problem.

Toni Morrison

On her point of view as a novelist:

There should be the illusion that it's the characters' point of view, when in fact it isn't; it's really the narrator who is there but who doesn't make herself (in my case) known in that role. I like the feeling of a *told* story, where you hear a voice but you can't identify it, and you think it's your own voice. It's a comfortable voice, and it's a guiding voice, and it's alarmed by the same things that the reader is alarmed by, and it doesn't know what's going to happen next either. So you have this sort of guide. But that guide can't have a personality; it can only have a sound, and you have to feel comfortable with this voice, and then this voice can easily abandon itself and reveal the interior dialogue of a character. So it's a combination of using the point of view of various characters but still retaining the power to slide in and out, provided that when I'm "out" the reader doesn't see little fingers pointing to what's in the text.

What I really want is that intimacy in which the reader is under the impression that he isn't really reading this; that he is participating in it as he goes along. It's unfolding, and he's always two beats ahead of the characters and right on target.

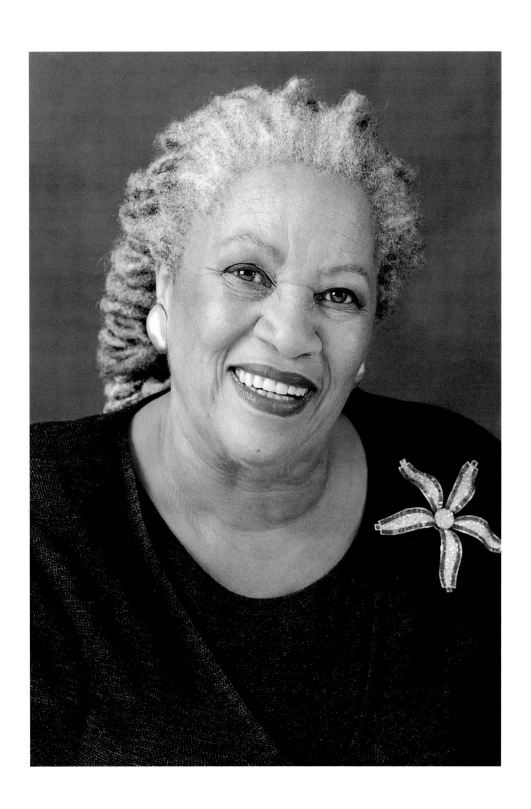

Jonathan Franzen

I don't trust a writer who is never funny, and I take it as an unfailingly bad sign if a book I'm writing fails to achieve comedy early on. I think the comic is intimately connected with the tragic—both perspectives signal to me that the writer can be trusted to put my interests as a reader ahead of the interests of the characters. I would no sooner fall in love with a humorless book than with a humorless woman.

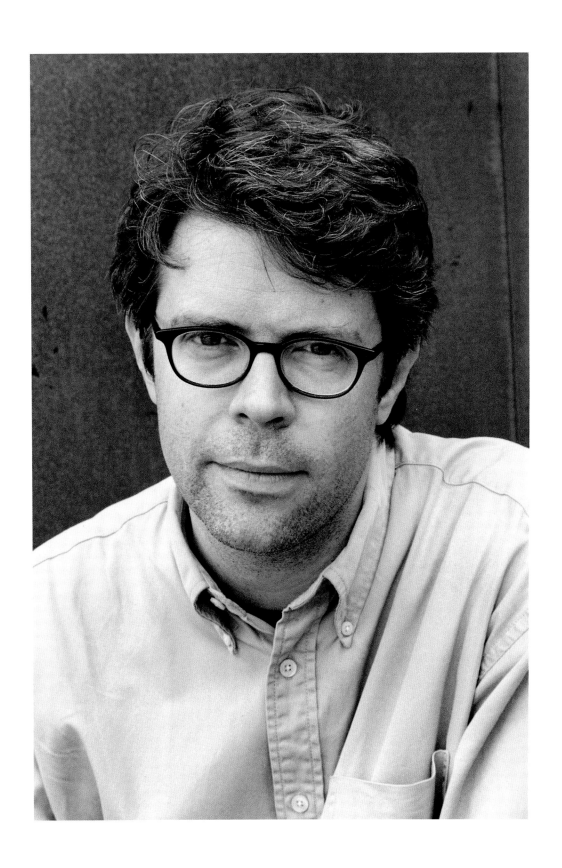

John Guare

I think the main obligation of a playwright is to break the domination of naturalism and get the theater back to being a place of poetry, a place where language can reign. Theater poetry is not just highfalutin language you spray on the event like Fry's *Venus Observed.* Theater poetry is response to the large event, events that force the poetry. It took me a very long time to realize the mythic size of Ibsen, to see that the mechanics of plot in an Ibsen play function the same way that fate does in Greek tragedy. Truth does not exist merely in the actor feeling the heat of the teacup. Behavioral naturalism belongs to television acting and movie acting. Theater acting should be closer to Cyrano de Bergerac or Falstaff or Edmund the Bastard. Or Ethel Merman. It's about finding truth on the large scale with the recognition of the actor as performer. In real life we're all such performers. Naturalism wants to reduce us. Naturalism always seems to be the most unnatural thing.

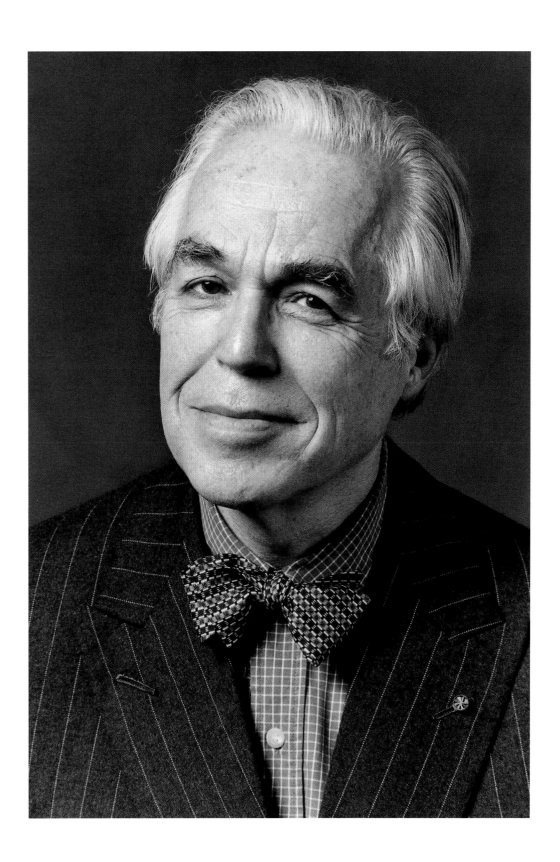

Jhumpa Lahiri

When I began writing fiction seriously, my first attempts were, for some reason, always set in Calcutta, which is a city I know quite well as a result of repeated visits with my family, sometimes for several months at a time. These trips, to a vast, unruly, fascinating city so different from the small New England town where I was raised, shaped my perceptions of the world and of people from a very early age. I went to Calcutta neither as a tourist nor as a former resident—a valuable position, I think, for a writer.

The reason my first stories were set in Calcutta is due partly to that perspective—that necessary combination of distance and intimacy with a place. Eventually I started to set my stories in America, and as a result the majority of stories in *Interpreter of Maladies* have an American setting. Still, though I've never lived anywhere but America, India continues to form part of my fictional landscape. As most of my characters have an Indian background, India keeps cropping up as a setting, sometimes literally, sometimes more figuratively, in the memory of the characters.

The Namesake is, essentially, a story about life in the United States, so the American setting was always a given. The terrain is very much the terrain of my own life—New England and New York, with Calcutta always hovering in the background. Now that the writing is done I've realized that America is a real presence in the book; the characters must struggle and come to terms with what it means to live here, to be brought up here, to belong and not belong here.

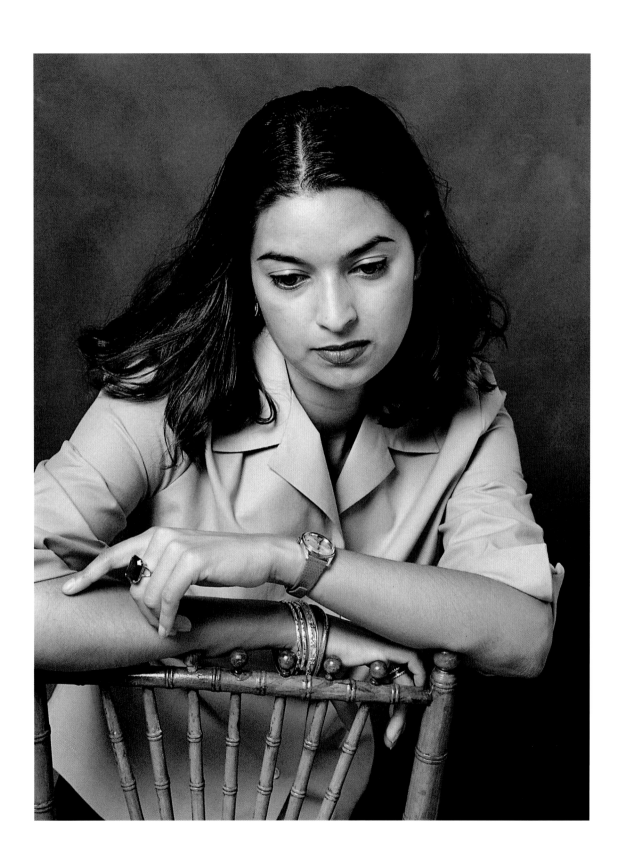

David Mamet

I didn't really start writing plays till I was in my twenties. And I started because the company, the St. Nicholas Theatre, couldn't pay any royalties—we didn't have any money. I was very fortunate coming from Chicago, because we had that tradition there of writing as a legitimate day-to-day skill, like bricklaying. You know, you need to build a house but you can't afford it, or you need to build a garage but you can't afford a bricklayer. Well, hell, figure out how to lay bricks. You need a script, well, hell, figure out how to write one. There was a great tradition flourishing in Chicago in the early seventies of the theater as an organic unit. The organic theater—in fact, the most important theater at the time was called the Organic Theater—but the organic (small *o*) theater consisted of a company of actors who also directed and also wrote and also designed. Everybody did everything. There was no mystery about it. One week one guy would be the director, the next week the woman would be the director and the guy would be acting, etc. So that was the community and the tradition in the seventies in Chicago.... It was all happening, all the time, like jazz in New Orleans. We looked at New York as two things: one was, of course, the Big Apple and the other was the world's biggest hick town. Because much of what we saw happening in New York was the equivalent of the Royal Nonesuch—you know, a bunch of people crawling around, barking and calling it theater. But the version in Chicago was people went to the theater just like they went to the ball game: they wanted to see a show. If it was a drama, it had to be dramatic, and if it was a comedy, it had to be funny—period. And if it was those things, they'd come back. If it wasn't those things, they wouldn't come back.

Ian McEwan

In my early twenties I was reading a lot of contemporary English fiction, and I felt stifled. These novels were nicely modulated, full of narrow observations about class status and furniture. Around the same time, I was reading a number of American writers: Miller, Burroughs, Roth. And also Bellow and Updike. I was struck by their vigor and freedom, and their sexual expressiveness. Then I saw what I wanted—something savage and dark. I always used to deny this, but I guess what I'm really saying is that I was writing to shock. I was impatient with the kind of fiction that was being written in England. It lacked true literary ambition. All these freedoms won for fiction, for consciousness, by people like Joyce and Lawrence and Virginia Woolf seemed to have been abandoned. We were back with a dull kind of realism—mere sociology. I was fired up and I felt impatient. So I dug deep and dredged up all kinds of vile things which fascinated me at the time. They no longer do, but they did then.

Shirley Hazzard

I feel that—analogous to life itself—a writer's ability to develop, and even to continue to produce at all, to a large measure depends on a capacity for self-questioning. The important inward questions are usually simpler in youth. As one grows older, they grow more challenging, and often more threatening. The strength to persevere with the process (not a systematic one, of course, in any usual meaning of the term) of self-enquiry is, I believe, in many cases closely related to the quality of a novelist's later work. A failure of courage or objectivity in this respect is not infrequently signalled by inability to write at all, or by the production of work that may be laboured or self-indulgent: books that merely rework, without developing them, one's past themes; or that pay off old scores. At any rate, this is a phenomenon I have experienced and observed, and which is I think notable among certain writers of the past, whose body of work is completed and can be considered with detachment.

Of course the quality of books will vary in any case. A disappointing book may well precede a strong one. Some work is a rehearsal—too often performed in public—of the real show. And then again, the sifting of a theme may simply intimidate a writer who cannot face the labour, the endurance, the discouraging fatigue, of bringing the material to life in its full power. To my mind, that again would be related to an ability for self-awareness. How can one undertake, with any confidence, to portray the inner reality, the motives and consciousness of others, if one has not applied such tests to oneself? I'm not advocating some orgy of self-accusation: rather, the application, as far as possible, of the same critical objectivity, the limiting of extenuation, to oneself, just as one applies this to others. The same inevitable degree of irony; the same weighing even of the sources of virtue—after all, if one believes in one's good qualities, they should be able to withstand enquiry. All one's perception should, ideally, first be sharpened on oneself.

Norman Rush

I think we would like to love our species, if we could. And I think that if we are even a little educated, we know how limited is our individual ability to see around or through the influences that have shaped our powers to understand the world and ourselves. We resemble, individually, sufferers from agnosia, a perceptual disorder whose victims are able to identify the properties of an object without being able to recognize what the object is.... We can love our species because we are ordered to by the spiritual director of our choice, or we can attempt, by passing through the alternative lives serious fiction brings us, to assemble a truer composite of what we are, with the intent of discovering, in the process, to what degree we should enlarge or qualify the baffled unformed sympathy we begin with. In stories or the novel, we are privileged to enjoy the least constrained representation of life achievable in any communicative form. Expository writing can't help but declare its viewpoint, and we normally know the bearing of the real lives presented in biography and autobiography before we begin, because the reputation of the subject alerts us. In serious fiction, we are able to enter disarmed and to open ourselves to the healthy subversions produced by the truth told excessively and beautifully and from vantage points different from our own and different from one another. Truth is a product of collaboration. We writers know it, and that's why, despite the ineliminably rivalrous atmosphere in which we work, we feel ourselves uplifted—for a time, anyway—by the occasional triumphs of our peers in seizing and displaying a life that tells things no life has ever told us before.

Junot Díaz

I've always had some weird space in my mind where stories take the form of radical geometries more than they take the form of sentences and paragraphs. I know this sounds more than odd but I don't see my stories as blocks of text at all—more like these weird 3-D paradigms that float in my brain. It's hard to describe but I guess all creative processes are. Through these forms I can sense a weakness or a gap or an inconsistency in my stories before I can even identify the problem in the language or in the character. I never realized how strange this shit actually was until I mentioned it to my friend George Saunders and he was just looking at me like I was nuts. This probably is why I write so slowly—trying to figure out what these shapes are telling me—but it's also why I feel I'm able to create some useful narrative structures without really thinking about it. This geometry thing works like an unconscious structural engine. I'll be writing, enjoying myself, not paying *any* kind of attention to the structure of the story, and yet part of me is working hard on it without fanfare or conscious deliberation.... I'll finish the first draft and there will be this amazing structure already in place. You know, amazing for me.

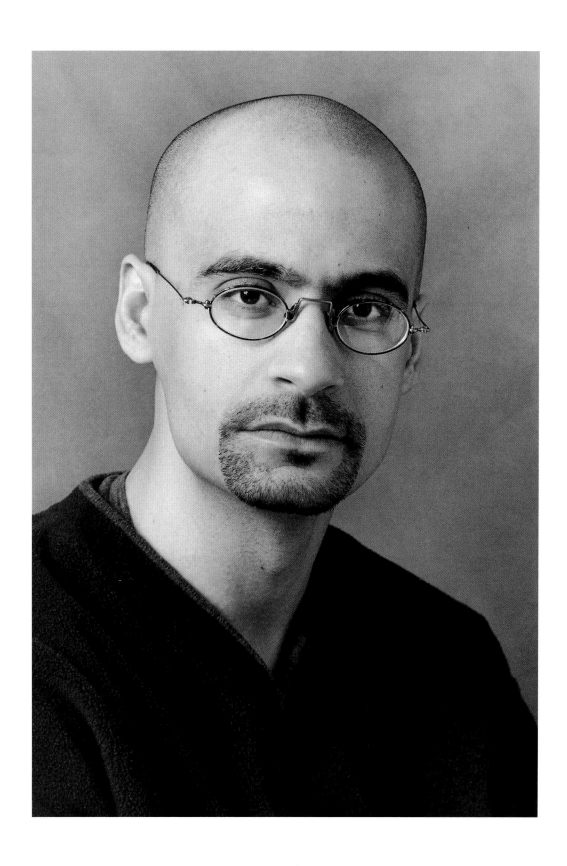

David Foster Wallace

For me the last few years of the postmodern era have seemed a bit like the way you feel when you're in high school and your parents go on a trip, and you throw a party. You get all your friends over and throw this wild disgusting fabulous party. For a while it's great, free and freeing, parental authority gone and overthrown, a cat's-away-let's-play Dionysian revel. But then time passes and the party gets louder and louder, and you run out of drugs, and nobody's got any money for more drugs, and things get broken and spilled, and there's a cigarette burn on the couch, and you're the host and it's your house too, and you gradually start wishing your parents would come back and restore some fucking order in your house. It's not a perfect analogy, but the sense I get of my generation of writers and intellectuals or whatever is that it's 3:00 A.M. and the couch has several burn holes and somebody's thrown up in the umbrella stand and we're wishing the revel would end. The postmodern founders' patricidal work was great, but patricide produces orphans, and no amount of revelry can make up for the fact that writers my age have been literary orphans throughout our formative years. We're kind of wishing some parents would come back. And of course we're uneasy about the fact that we wish they'd come back—I mean, what's wrong with us? Are we total pussies? Is there something about authority and limits we actually need? And then the uneasiest feeling of all, as we start gradually to realize that parents in fact aren't ever coming back—which means "we're" going to have to be the parents.

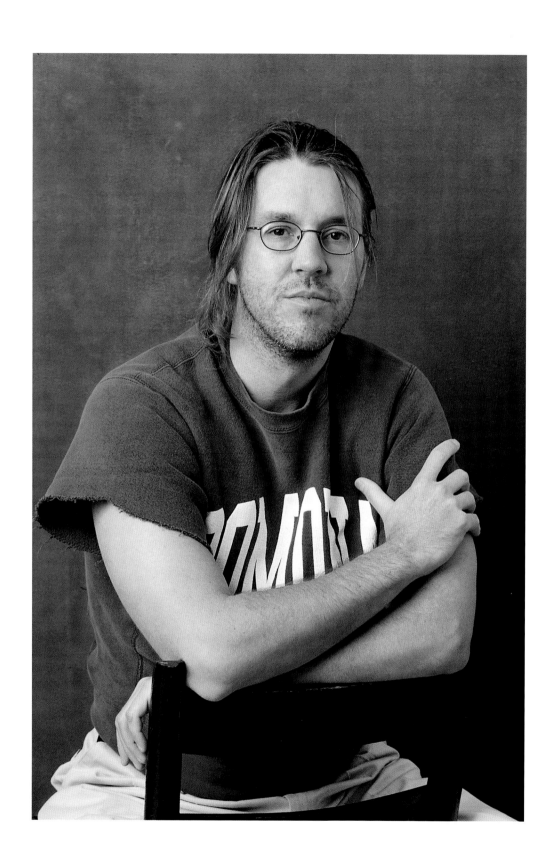

Studs Terkel

During my three years of prospecting, I may have, on more occasions than I had imagined, struck gold. I was constantly astonished by the extraordinary dreams of ordinary people.

I was no more than a wayfaring stranger, taking much and giving little. True, there were dinners, lunches, drinks, some breakfasts, in posh as well as short order places. There were earnest considerations, varying with what I felt was my companion's economic condition. But they were at best token payments. I was the beneficiary of others' generosity. My tape recorder, as ubiquitous as the carpenter's tool chest or the doctor's black satchel, carried away valuables beyond price.

On occasions, overly committed, pressed by circumstance of my own thoughtless making, I found myself neglecting the amenities and graces that offer mutual pleasure to visitor and host. It was the Brooklyn fireman who astonished me into shame. After what I had felt was an overwhelming experience—meeting him—he invited me to stay "for supper. We'll pick something up at the Italian joint on the corner." I had already unplugged my tape recorder. (We had had a few beers.) "Oh, Jesus," I remember the manner in which I mumbled. "I'm supposed to see this hotel clerk on the other side of town." He said, "You runnin' off like that? Here we been talkin' all afternoon. It won't sound nice. This guy, Studs, comes to the house, gets my life on tape, and says 'I gotta go'…" It was a memorable supper. And yet, looking back, how could I have been so insensitive?

In a previous work, a middle-aged black hospital aide observed, "You see, there's such a thing as a feeling tone. And if you don't have this, baby, you've had it." It is a question I ask myself just often enough to keep me uncomfortable. Especially since my host's gentle reprimand. Not that it was a revelatory experience for me. Though I had up to that moment succeeded in burying it, the thief-in-the-night, I knew it was there. The fireman stunned me into facing up to it.

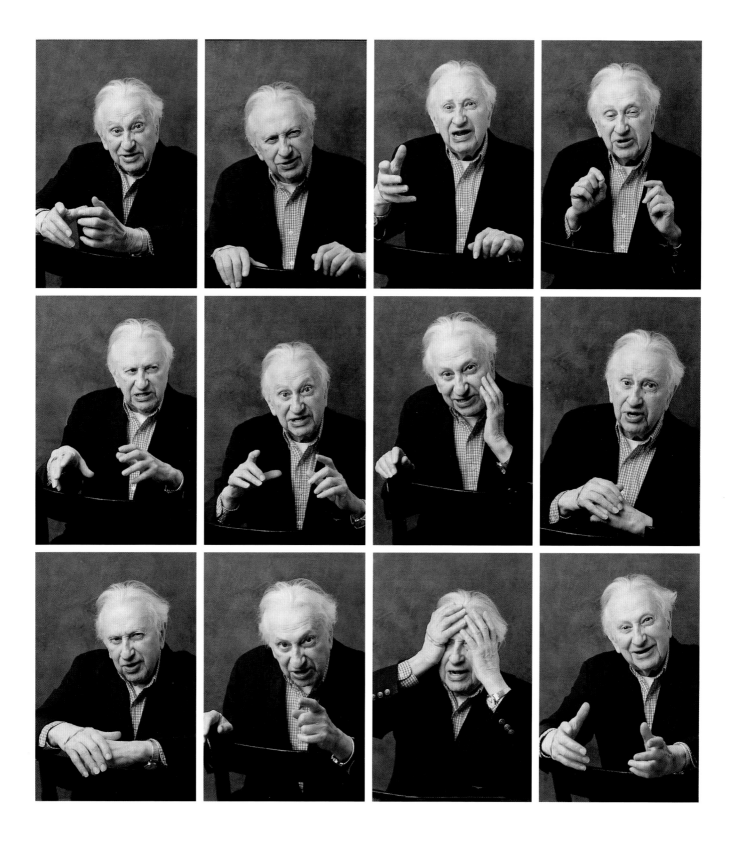

Afterword

It was a safari in East Africa in 1967 that inspired me to take up photography. Back in New York, I started working for the foreign press and soon discovered my vocation: to depict the artists and writers of my time. I had always been drawn to artists and writers, and not surprisingly, I found them to be the most engaging and challenging of subjects.

Here are some of the entries in my photographer's diary:

East Village, New York City, 1972. W. H. Auden is conveniently located in the Manhattan phone book, so I call him and take my first literary portrait at his parlor floor-through on St. Mark's Place.

A Boston suburb, 1973. It's Sunday, and Anne Sexton, with a string of suicide attempts in her dossier, is checking herself into McLean Hospital tomorrow. But she doesn't cancel our appointment. The result is a penetrating inner portrait.

Ossining, New York, 1976. John Cheever is sitting at the bottom of a flight of stone steps when his Labrador appears at the top, echoing Cheever's pensive pose. A found photograph.

Litchfield County, Connecticut, 1983. I make up my mind to shoot Philip Roth on one of the local country roads. After the third or fourth road, Philip says, "Nancy, the road didn't write the book."

A park bench by the East River, New York City, 1984. People tell me it's too late to do Truman Capote—he's a wreck. They're proved wrong: he comes through smashingly in a photo taken only three months to the day before he gives out.

St.-Paul-de-Vence, 1986. In a rustic courtyard on the outskirts of town, James Baldwin appears, barefoot, in a startling white djellaba. Have I died and gone to heaven? I take pictures in the early evening light, miss the last bus, and hitchhike back to Antibes as night falls.

Jackson, Mississippi, 1991. I call her Miss Welty. But Eudora says straight off, in her soft Southern accent that is music to my Northern ears, "I think you better call me by my other name."

Greenwich Village, New York City, 2004. Studs Terkel, ninety-one, stops by my place for a brief photo session and decides to tell a story. What I need is a tape recorder!

From the beginning of this episodic freelance life, my favorite camera has been an old 35mm rangefinder, the Leica M3, last manufactured in 1964, plus a 50mm lens, with Tri-X 400 for my black-and-white film. I like to work as simply as possible.

Since 1988 I have had the agreeable job of being official photographer for the Unterberg Poetry Center at the 92nd Street Y. Eighteen of these photos—of playwrights and novelists as well as poets—were taken backstage before the Y's legendary Monday night readings.

My thanks to all the writers who sat for my camera over the years, particularly those who lent their words to this project. Also a footnote is due to George Plimpton's Mr. Puss, Dick Wilbur's Daisy, Jim Salter's Sumo, Bill Steig's Alan, and John Cheever's Flora Macdonald.

Finally, special thanks to the Boston Athenæum, the Leica Gallery in New York City, and the Los Angeles Public Library for presenting exhibitions of many of the photographs in this book.

<div style="text-align: right">

Nancy Crampton
New York City

</div>

Acknowledgments

Grateful acknowledgment is made for permission to reprint excerpts from *The Paris Review* interviews with Chinua Achebe, Edward Albee, Maya Angelou, John Ashbery, Margaret Atwood, W. H. Auden, Beryl Bainbridge, John Barth, Harold Bloom, Harold Brodkey, Joseph Brodsky, Truman Capote, Ralph Ellison, William Gaddis, Gabriel García Márquez, Günter Grass, John Guare, Seamus Heaney, John Irving, Christopher Isherwood, Stanley Kunitz, Robert Lowell, David Mamet, Peter Matthiessen, William Maxwell, Arthur Miller, Lorrie Moore, Alice Munro, Iris Murdoch, V. S. Naipaul, Joyce Carol Oates, Edna O'Brien, S. J. Perelman, Philip Roth, James Salter, Anne Sexton, Sam Shepard, Isaac Bashevis Singer, Robert Stone, Tom Stoppard, Mark Strand, Kurt Vonnegut, Derek Walcott, Robert Penn Warren, and Tom Wolfe. Copyrighted by The Paris Review Foundation, Inc., and reprinted by permission of The Wylie Agency, Inc.

Further acknowledgments for *Paris Review* excerpts include:
© Chinua Achebe; Harold Brodkey, by permission of Inkwell Management, Inc.; The Truman Capote Literary Trust, Alan U. Schwartz, Trustee; Copyright © 1955 by Ralph Ellison. Reprinted by permission of William Morris Agency, Inc., on behalf of the Author; Copyright © 1989 Günter Grass; John Irving: © Garp Enterprises, Ltd.; Copyright © 1961 Robert Lowell. Reprinted by permission of Farrar, Straus and Giroux, LLC, on behalf of Harriet Lowell and Sheridan Lowell; William Maxwell, by permission of The Wylie Agency, Inc.; Interview with Sir V. S. Naipaul, Copyright © 1998, by permission of Gillon Aitken Associates, Ltd.; S. J. Perelman, by permission of Harold Ober Associates Incorporated; © Sam Shepard; Isaac Bashevis Singer, by permission of Lescher & Lescher, Ltd.; Copyright © 1957 by Robert Penn Warren. Reprinted by permission of William Morris Agency, Inc., on behalf of the Author.

Grateful acknowledgment is made for permission to reprint excerpts from the following material:
Conversations with Nelson Algren by H. E. F. Donohue and Nelson Algren. Copyright 1964 by H. E. F. Donohue and Nelson Algren, copyright renewed 1991 by Robert Joffe. Reprinted by permission of Hill and Wang, a division of Farrar, Straus and Giroux, LLC.
"The Black Scholar Interviews James Baldwin," *The Black Scholar,* 1973, 5, Dec. 1973–Jan. 1974. Reprinted by permission of The Black Scholar.
"Literature in the Age of Technology," lecture, Fall 1972. By permission of Saul Bellow.
This Craft of Verse: The Charles Eliot Norton Lectures 1967–1968 by Jorge Luis Borges, edited by Calin-Andrei Milhailescu, p. 97, Cambridge, Mass.: Harvard University Press, Copyright © 2000 by the President and Fellows of Harvard College. Reprinted by permission of the publisher.
The Restaurants of New York, 1978–1979 Edition, Random House. © 1978 Seymour Britchky.
"Update on *Part One:* An Interview with Gwendolyn Brooks," Gloria T. Hull and Posey Gallagher. *CLA Journal* 21: 19–40. By permission of The College Language Association.
"Bold Type: Interview with Peter Carey," courtesy of Random House.
Preface to *The Stories of John Cheever,* Alfred A. Knopf. © 1978 by John Cheever, reprinted with the permission of The Wylie Agency, Inc.
People Are Talking, radio interview with Laurie Colwin by Sally Spillane.
Interview with Junot Díaz by Marina Lewis, *Other Voices,* Spring/Summer 2002.
James Dickey interview with David L. Arnett, from L. S. Dembo, ed. *Interviews with Contemporary Writers: Second Series, 1972–1982.* Reprinted by permission of University of Wisconsin Press.
The Writing Life, Marie Arana, ed., Public Affairs, 2003. First published in *The Washington Post Book World.* © E. L. Doctorow.
A letter from Nathan Englander to Sasha Heman, Dec. 3, 2001.
"Jonathan Franzen by Donald Antrim," *BOMB Magazine* interview.
Here at The New Yorker by Brendan Gill, Random House, 1975. Reprinted by permission of the Gill family. All rights reserved.
Writing and Being by Nadine Gordimer, pp. 2–3, Cambridge, Mass.: Harvard University Press, Copyright © 1995 by Nadine Gordimer. Reprinted by permission of the publisher.
"Shirley Hazzard, Astronomer of Souls." Paul Kavanaugh, interviewer, *Southerly,* Number 2, 1985.
Conversations with American Writers by Charles Ruas, Alfred A. Knopf, 1985. Interviews with Joseph Heller and Tennessee Williams.
"Gayl Jones: An Interview," *Chant of Saints: A Gathering of Art, Literature and Scholarship,* University of Illinois Press, © 1979 Michael S. Harper and Robert B. Stepto, co-editors.

Index